LEARNING TO LOOK *A Handbook for the Visual Arts*

LEARNING TO

LOOK *A Handbook for the Visual Arts*

SECOND EDITION

By JOSHUA C. TAYLOR

THE UNIVERSITY OF CHICAGO PRESS

CHICAGO AND LONDON

Library of Congress Cataloging in Publication Data

Taylor, Joshua Charles, 1917–
 Learning to look.

 Includes index.
 1. Art appreciation. I. Title.
 N7477.T39 1981 701'.1 80-26251

 ISBN 0-226-79154-8 (pbk.)

The University of Chicago Press, Chicago 60637
The University of Chicago Press, Ltd., London

 © 1957, 1981 by The University of Chicago
 All rights reserved. Published 1981
 Printed in the United States of America

00 99 9 10 11 12

TABLE OF CONTENTS

CHRONOLOGICAL TABLE

INDEX

PREFACE TO THE
SECOND EDITION

It is gratifying to know that, although the course at the University of Chicago for which it was prepared has long since ceased to exist in its original form, this little book has continued to be of use to universities, museums, and those interested in art throughout the country. In preparing this new edition I have changed very little, principally adding a short chapter intended to be of use in considering some aspects of more recent art and bringing the chronological table up to date. I hope that in its present form it will prove for some years more to be helpful to those engaged in the pleasurable study of the visual arts.

August 1980

JOSHUA C. TAYLOR

PREFACE TO THE FIRST EDITION

The materials brought together in this book have served for some years, in rather different form, as introduction and handbook of reference to the art portion of the initial humanities course at the University of Chicago. This required course, known as Humanities 1, extends over the entire academic year and includes study in music and literature as well as in the visual arts. Although the present book serves the content of only one-third of the course, that third, in the practice of the University of Chicago, extends over the entire period, allowing time for the student to test and deepen the ideas presented through extended experience of his own.

In the presentation of each of the arts, it has been a guiding premise of the course staff that all study, whether critical or historical, logically begins with the work of art itself. This in no sense means, as becomes clear during the progress of the course, that the study of a work stops with what can be immediately seen or heard. This is only the beginning. But unless the student has become critically aware of and has learned to define his own immediate experience in confronting a work of art, the superstructure of history, critical theories, and other elucidating systems (including those of purely formal analysis) may effectively smother the all-important spark of vitality that separates the meaningful study of art from a routine academic exercise. Seeing, we have found, is sometimes more difficult for the student of art than believing.

This book is a guide, actually, to only the first step in the study of art. But, we would maintain, it is a very important step indeed. However, whether the first step is taken over the period of a year in conjunction with the other arts or as a

concentrated prelude to a chronologically organized course, we hope that our handy reference and guide may be of use.

It should be explained that this book has been considered as reference and guide, rather than as text, in our own teaching. In the lectures and the more frequent class discussions, new material is used to expand the ideas developed in the book, giving the student opportunity to try out for himself the procedures and information to which the book has introduced him. For example, if, rather than going back simply to the book's examples, one examines a very different painting of the Crucifixion, say one by Rubens, after a reading of the first chapter, many new qualities become evident and demand new formulations and expression. Better still, if works of entirely different subject matter are considered, such as the boisterous "Wedding Dance" of Brueghel or a *fête champêtre* of Watteau, the questions raised concerning the expressiveness of form and color can be put to a fresh and revealing test. Nor do we think of the terms and methods used in the text as being in any way definitive or restrictive. They only point the way.

The organization of the book is cumulative in character, progressing in a sense from the simple to the complex, yet never losing sight of the simple beginning. The student is first asked to concentrate on the expression and construction of the work itself without reference to historical or technical associations. Secondly, he is introduced to the wide range of possible experiences in art afforded by various technical and creative processes, coming at the same time closer to an understanding of the work of art as related to the artist. Chapter iv serves as a reference section to this study. Finally, the work is considered as a part of the artist's *œuvre* and, as such, in relationship to other works in a historical dimension. We should like to suppose that after such an introduction the student is prepared to proceed to a profitable study either of history or of criticism.

Over the years many staff members have written portions of the "Humanities 1 Handbook," as it has been called, in its various forms. Among these have been Messrs. Joseph Fulton, James I. Gilbert, Harold Haydon, and Bates Lowry. In bringing the material together for this publication, however, I have taken rather extensive liberties with many of those portions I have used from earlier editions. The members of the staff have participated most helpfully in criticizing and suggesting improvements in the present work. I am particularly indebted to Messrs. Maurice B. Cramer and Albert M. Hayes for their careful

reading of the text and their many helpful suggestions, and to Mr. Alan M. Fern for his help in preparing the plates. The line drawings in chapter iv are by Mr. Haydon, who also contributed a major portion of the technical sections on graphic art, sculpture, and architecture in that chapter. The informal sketches appearing elsewhere in the text are my own contribution, intended to be looked at no more intently than those hasty diagrams that any professor sketches on the blackboard when a simple visual symbol seems clearer than words alone to convey a meaning.

In choosing the examples to illustrate the book we have been guided by the dual principle of clarity and variety. Although the illustrations in no sense provide a brief review of masterpieces or a concise history of art, we hope that through their variety in both period and kind they will suggest the wide range of experience to be explored in the field of art. In selecting works for discussion in the course itself at Chicago, we recognize the further obligation to introduce the student to great and important works as well as to develop his capacities of observation and judgment, thus providing him with a repertory of high quality against which new experiences can be tried. We strongly believe also in the use of original works wherever possible to offset the remote dryness of reproductions and slides. In this respect, of particular importance is the study of original works outside class, by which a student may develop a sense of his own capacity to enjoy a work of art.

Our "Handbook" has served us well in the past, and we hope that in its present revised form, made possible by a grant from the Fund for the Advancement of Education, it will be of equal service to others.

<div align="right">JOSHUA C. TAYLOR</div>

ILLUSTRATIONS

LIST OF ILLUSTRATIONS

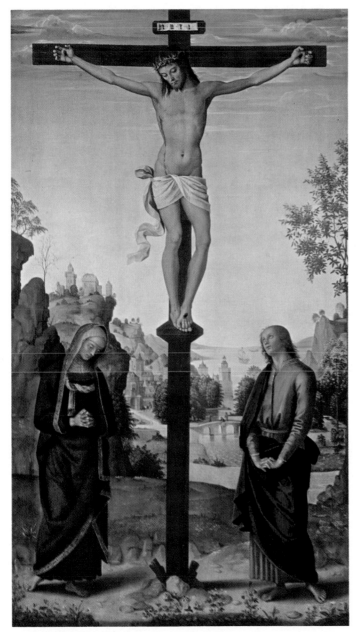

National Gallery of Art, Washington, D.C., Mellon Collection

PLATE I.—PIETRO PERUGINO, "THE CRUCIFIXION WITH SAINTS"
(CENTRAL PANEL, $39\frac{7}{8} \times 22\frac{1}{4}$ IN.)

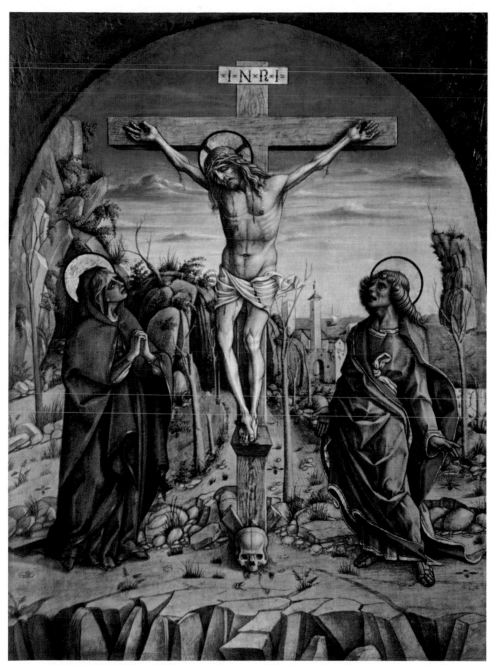

PLATE II.—CARLO CRIVELLI, "THE CRUCIFIXION" ($30\frac{5}{16} \times 22\frac{3}{4}$ IN.)

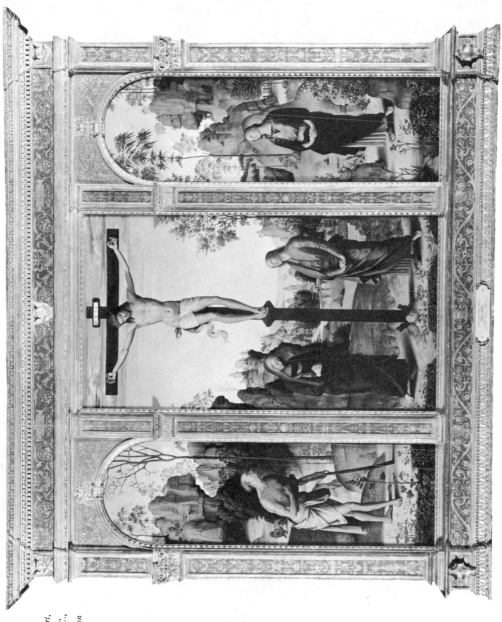

Fig. 1.—Pietro Perugino,
"The Crucifixion with Saints"
($39\frac{7}{8} \times 46\frac{1}{4}$ in.)

9

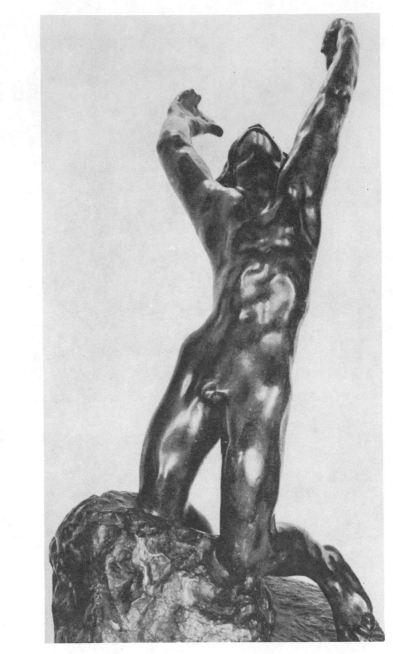

FIG. 2.—AUGUSTE RODIN, "THE PRODIGAL SON" (54 × 28 × 34½ IN.)

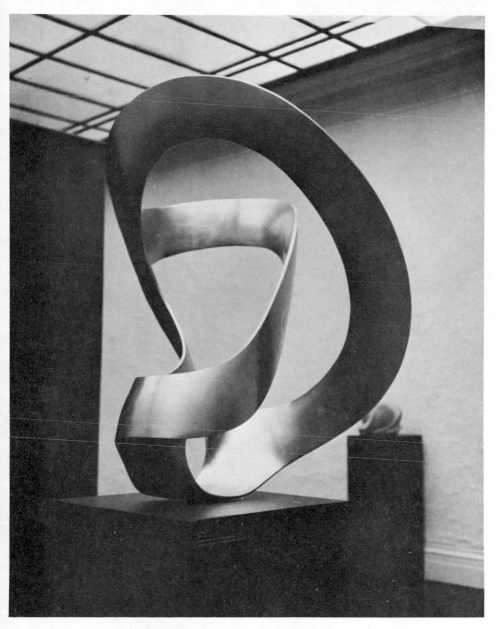

FIG. 3.—MAX BILL, "TRIPARTITE UNITY" (46 IN. HIGH)

FIG. 4.—ANDREA PALLADIO, VILLA CAPRA (ALSO CALLED VILLA ROTONDA), VICENZA, ITALY

Edmund Teske Photo

FIG. 5.—FRANK LLOYD WRIGHT, JOHN C. PEW HOUSE, SHOREWOOD HILLS, WISCONSIN

Fig. 6.—J. A. D. Ingres, "Charles-François Mallet" ($10\frac{9}{16} \times 8\frac{5}{16}$ in.)

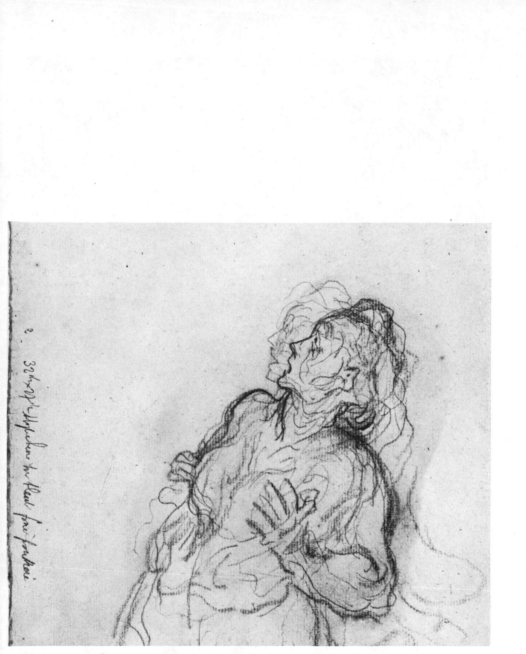

FIG. 7.—HONORÉ DAUMIER, "FRIGHT" ($7\frac{15}{16} \times 9\frac{1}{4}$ IN.)

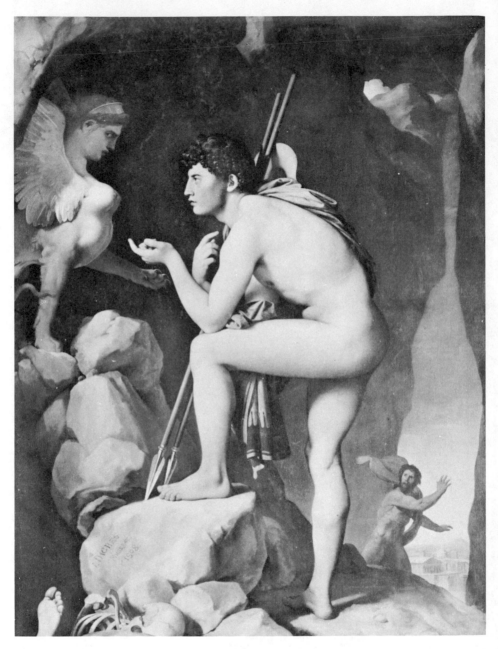

FIG. 8.—J. A. D. INGRES, "OEDIPUS AND THE SPHINX" ($74\frac{1}{2} \times 56\frac{2}{3}$ IN.)

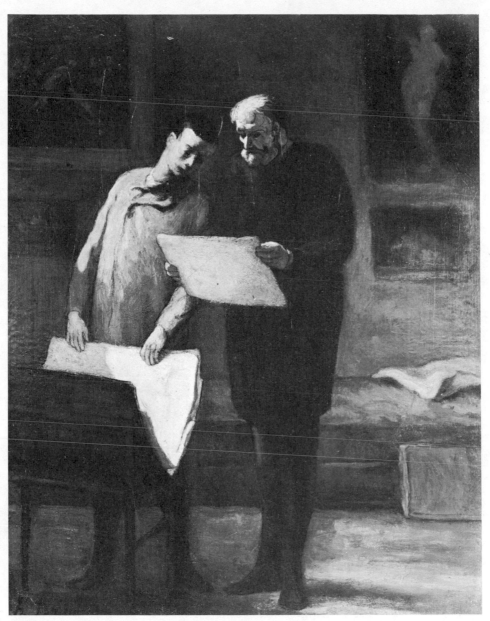

FIG. 9.—HONORÉ DAUMIER, "ADVICE TO A YOUNG ARTIST" ($16\frac{1}{8} \times 12\frac{7}{8}$ IN.)

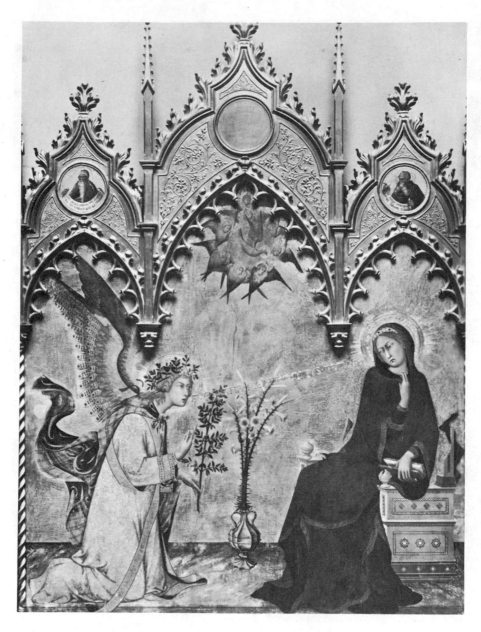

FIG. 10.—SIMONE MARTINI, "ANNUNCIATION" (104⅛ × 120⅛ IN.)

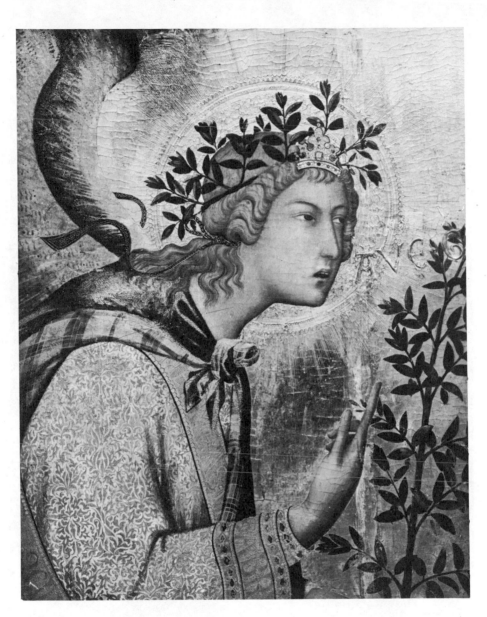

FIG. 11.—SIMONE MARTINI, DETAIL FROM "ANNUNCIATION"

19

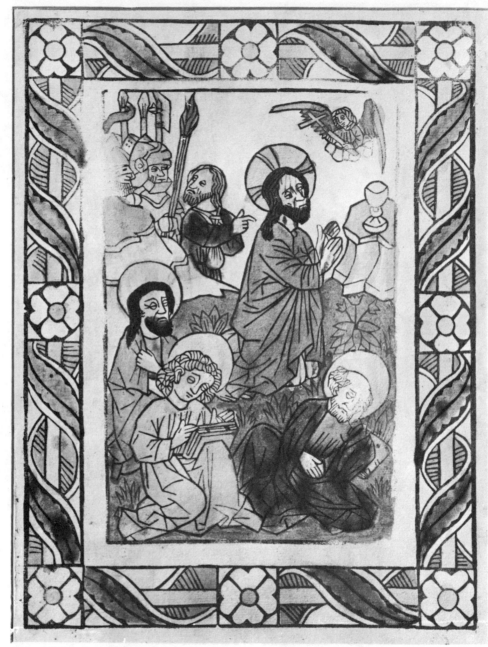

FIG. 12.—ANONYMOUS, "THE AGONY IN THE GARDEN" (WOODCUT; SWABIAN, CA. 1450–60; INCLUDING BORDER: $9\frac{5}{16} \times 7\frac{1}{2}$ IN.).

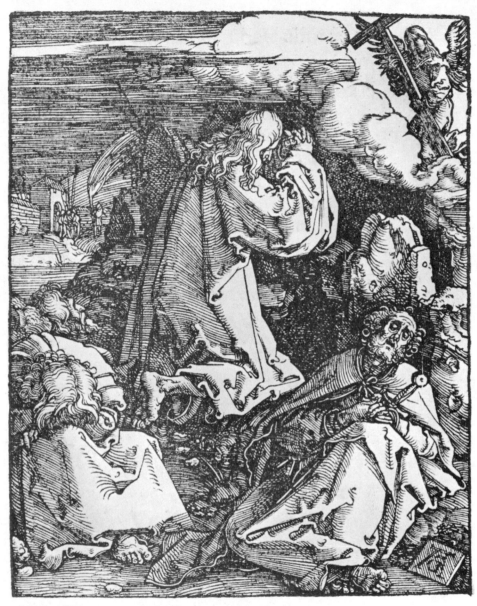

Fig. 13.—Albrecht Dürer, "The Agony in the Garden" (Woodcut from "The Little Passion," 1511; $5 \times 3\frac{7}{8}$ in.).

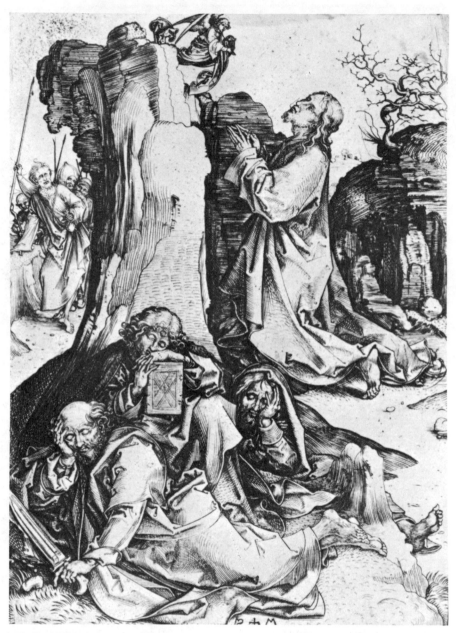

Fig. 14.—Martin Schöngauer, "The Agony in the Garden" (Engraving on Metal, 6½ × 4½ in.).

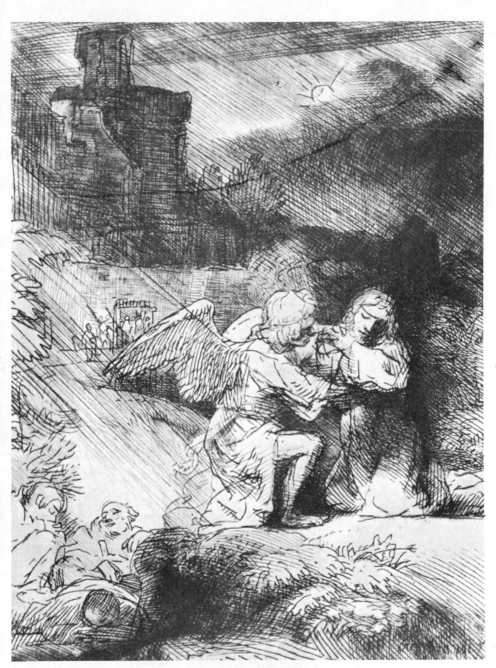

FIG. 15.—REMBRANDT VAN RIJN, "THE AGONY IN THE GARDEN" (ETCHING WITH DRYPOINT, $4\frac{1}{4} \times 3\frac{1}{4}$ IN.).

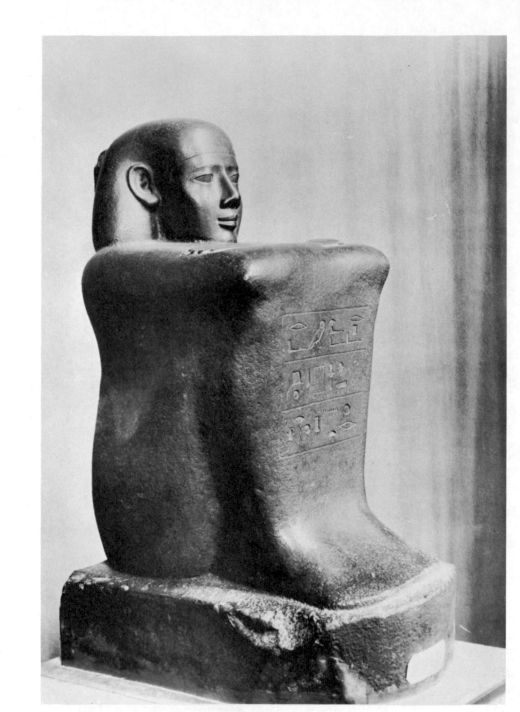

Louvre, Paris (Caisse Nationale des Monuments Historique Photo)

FIG. 16.—EGYPTIAN FIGURE, "OUAH AB RA"

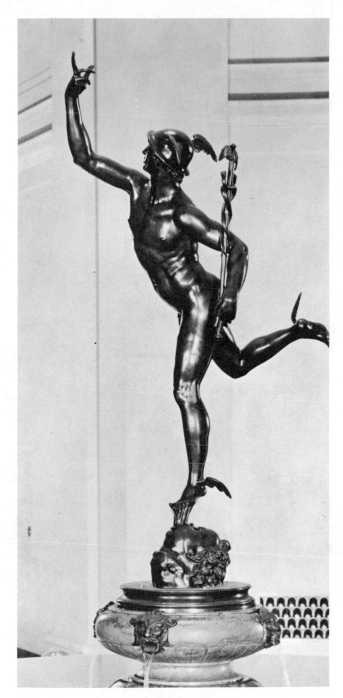

FIG. 17.—GIOVANNI DA BOLOGNA, "MERCURY" (69 IN. HIGH)

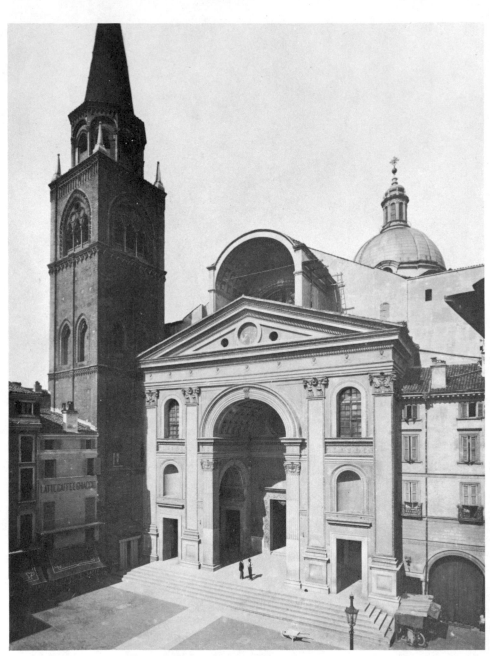

FIG. 18.—L. B. ALBERTI, CHURCH OF SANT'ANDREA (EXTERIOR), MANTUA

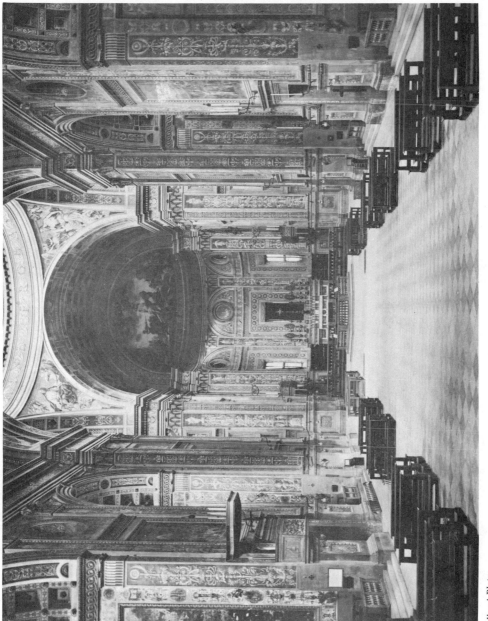

Fig. 19.—L. B. Alberti, Church of Sant'Andrea (Interior), Mantua

27

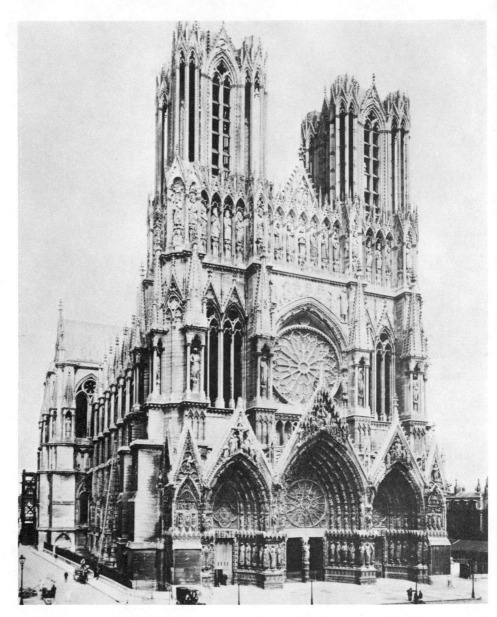

FIG. 20.—CATHEDRAL OF RHEIMS (EXTERIOR)

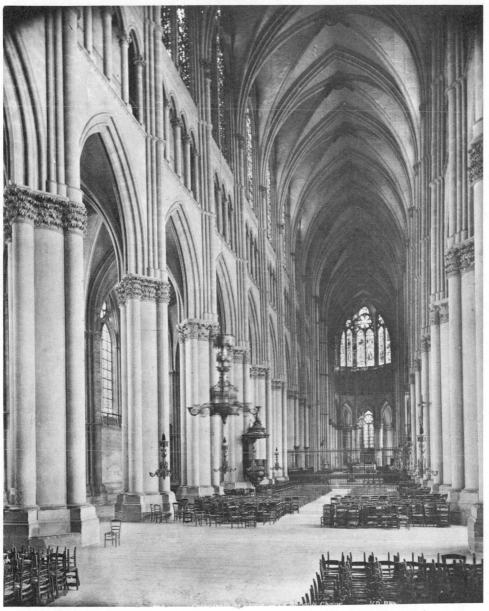

FIG. 21.—CATHEDRAL OF RHEIMS (INTERIOR)

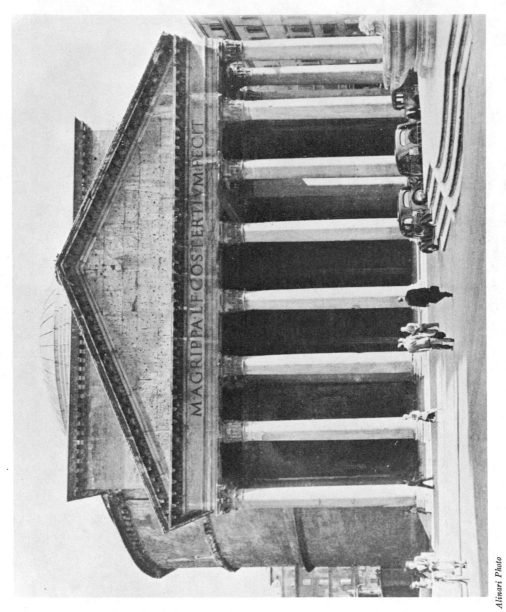

Fig. 22.—The Pantheon (Exterior), Rome

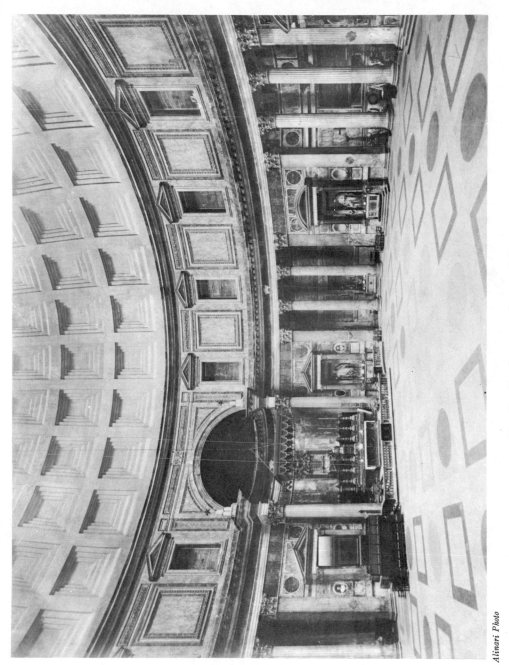

Fig. 23.—The Pantheon (Interior), Rome

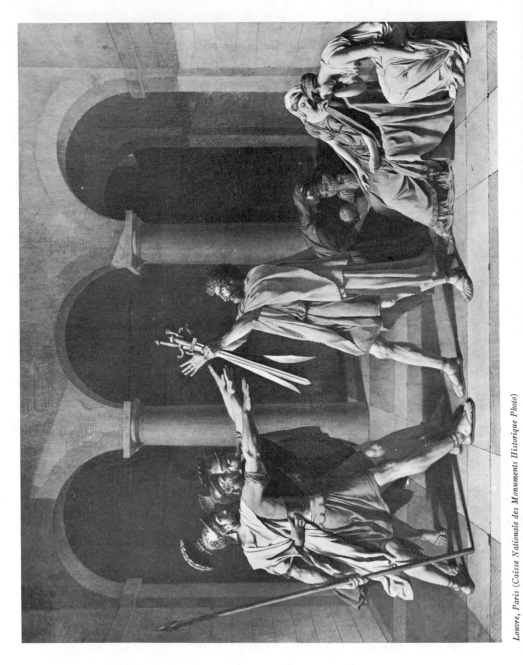

E. M. J. David, "The Oath of the Horatii" (130 × 168 in.)

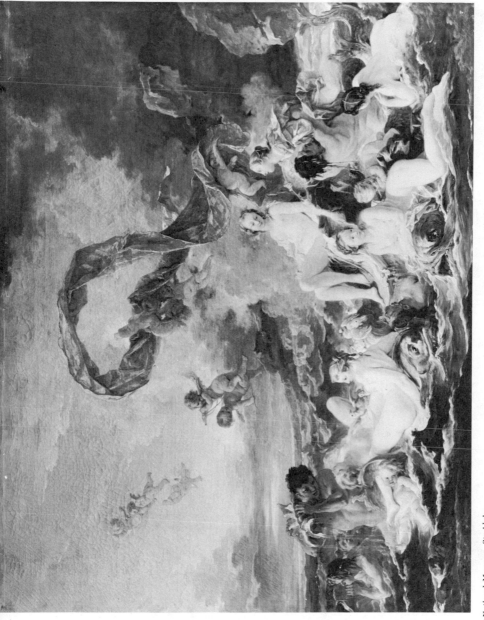

Fig. 25.—François Boucher, "The Triumph of Venus" (51 × 63¾ in.)

33

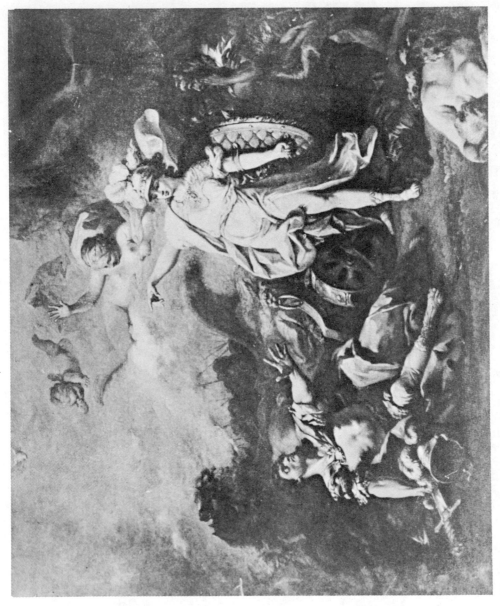

FIG. 26.—J. L. DAVID. "THE COMBAT OF MINERVA AND MARS." (45 × 55 IN.)

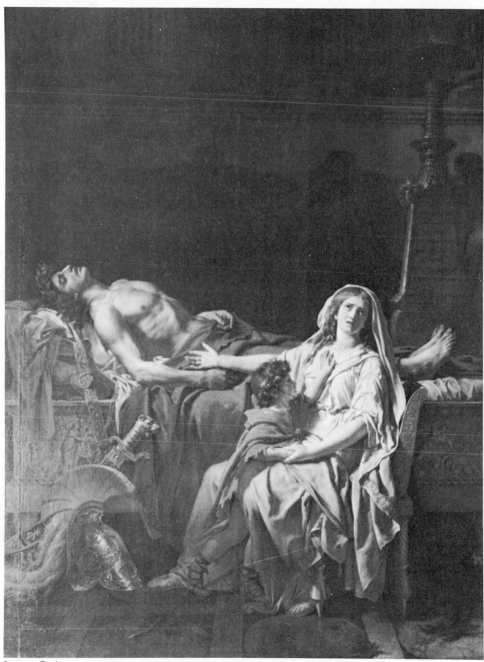

Fig. 27.—J. L. David, "Andromache Mourning beside the Body of Hector" (108¼ × 79⅞ in.).

35

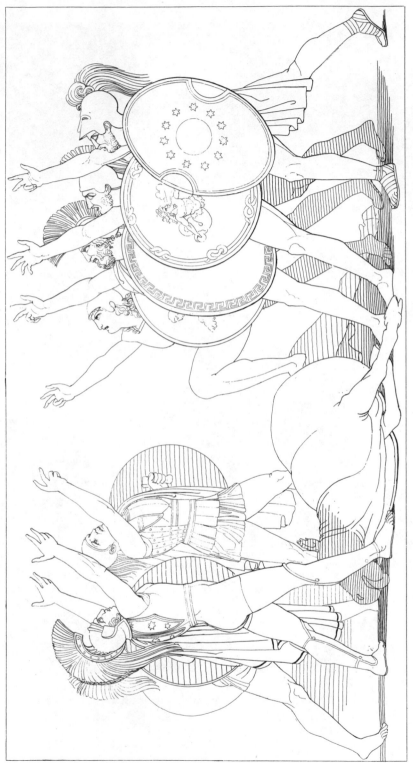

Illustration in Compositions from the Tragedies of Aeschylus (*London, 1831*)

FIG. 28.—JOHN FLAXMAN, "SEVEN CHIEFS AGAINST THEBES" ($7\frac{1}{2} \times 13\frac{3}{8}$ IN.)

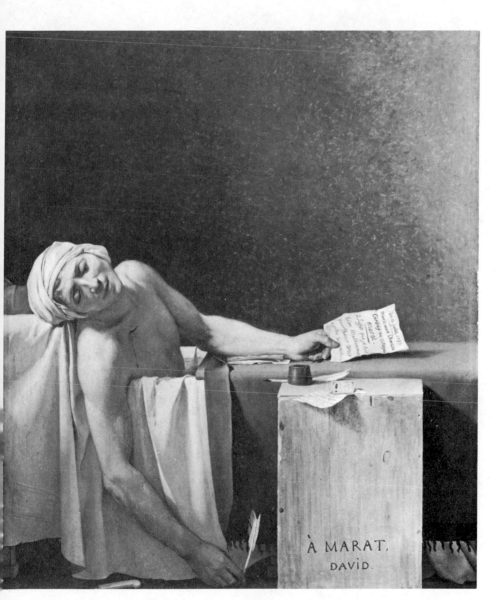

FIG. 29.—J. L. DAVID, "THE DEAD MARAT" ($63\frac{3}{4} \times 49\frac{1}{4}$ IN.)

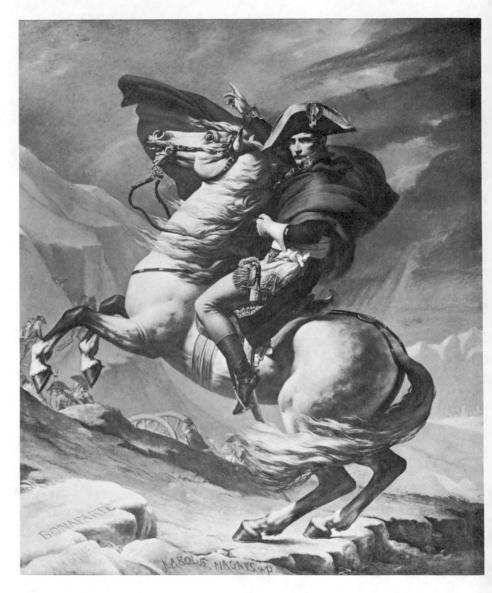

FIG. 30.—J. L. DAVID, "NAPOLEON CROSSING THE ST. BERNARD PASS" ($107\frac{1}{2} \times 91\frac{1}{2}$ IN.)

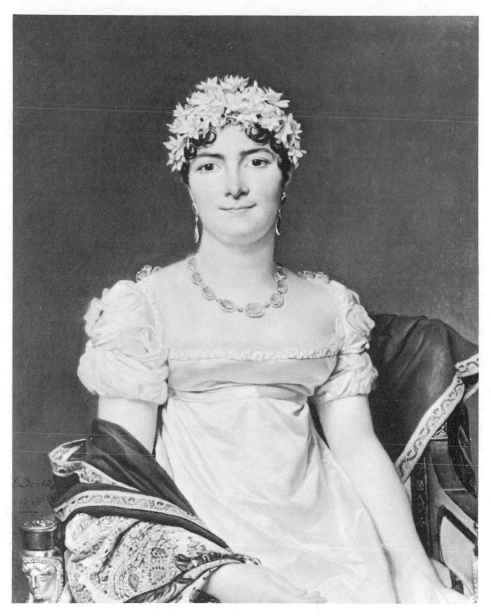

FIG. 31.—J. L. DAVID, "COUNTESS DARU" (32 × 25 IN.)

39

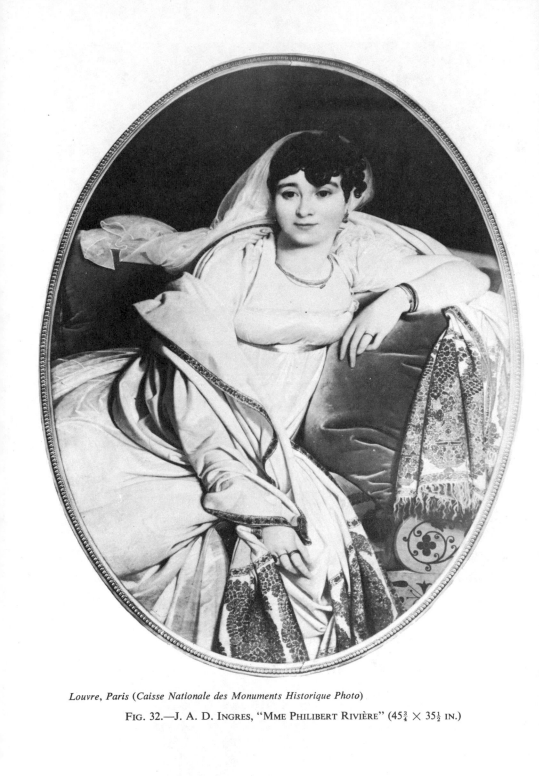

Louvre, Paris (*Caisse Nationale des Monuments Historique Photo*)

Fig. 32.—J. A. D. Ingres, "Mme Philibert Rivière" ($45\frac{3}{4} \times 35\frac{1}{2}$ in.)

The Phillips Collection, Washington, D.C.

FIG. 33.—PIET MONDRIAN, "PAINTING NO. 9," 1939–42 (31¼ × 29 IN.)

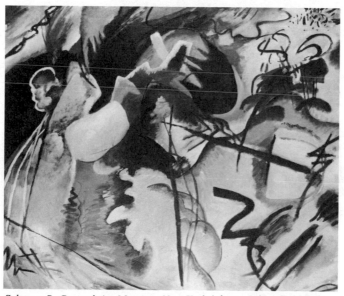

Solomon R. Guggenheim Museum, New York (photo: Robert E. Mates)

FIG. 34.—WASSILY KANDINSKY, "PAINTING WITH WHITE FORM," 1913 (47⅜ × 55 IN.)

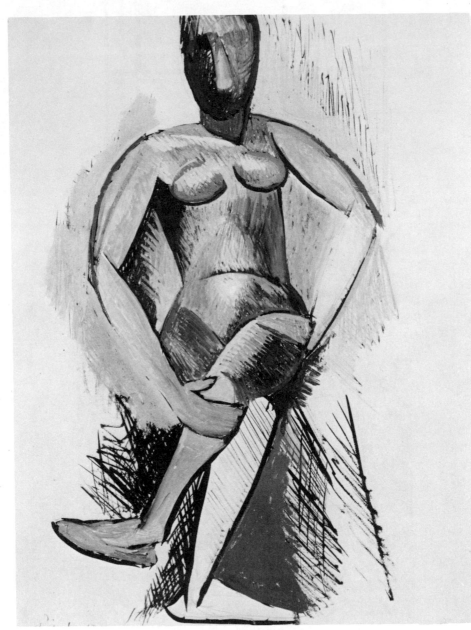

FIG. 35.—PABLO PICASSO, "SEATED NUDE," 1909 (24¾ × 19 IN.)

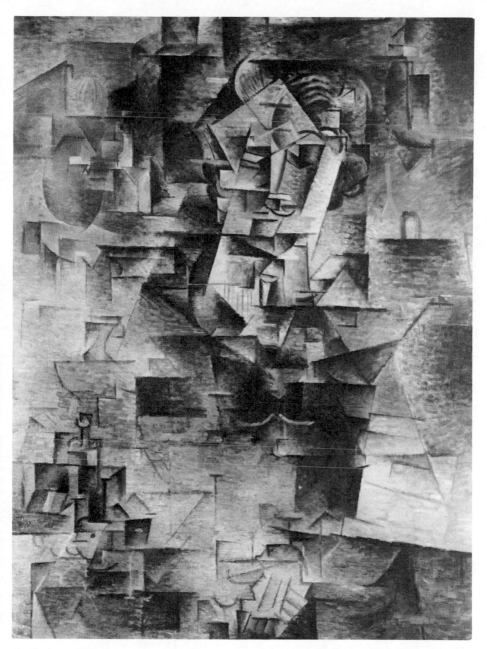

FIG. 36.—PABLO PICASSO, "PORTRAIT OF DANIEL-HENRY KAHNWEILER," 1910 ($39\frac{5}{8} \times 28\frac{5}{8}$ IN.)

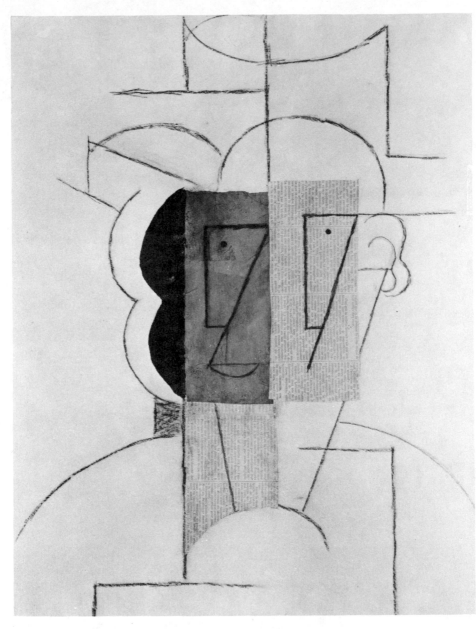

FIG. 37.—PABLO PICASSO, "MAN WITH A HAT," 1912 (24½ × 18⅝ IN.)

FIG. 38.—PAUL KLEE, "CHILD CONSECRATED TO SUFFERING," 1935 ($6\frac{1}{4} \times 9\frac{1}{4}$ IN.)

FIG. 39.—GEORGE SEGAL, "THE SUBWAY," 1968 (90 × 115 × 53 IN.)

Nelson Gallery–Atkins Museum, Kansas City, Missouri, Gift of the Guild of the Friends of Art

FIG. 40.—TOM WESSELMAN, "STILL LIFE #24," 1962 (48 × 59⅞ IN.)

National Museum of American Art, Smithsonian Institution, Washington, D.C.

FIG. 41.—IDELLE WEBER, "VAMPIRELLA—E. 2ND ST.," 1975 (24⅜ × 35 IN.)

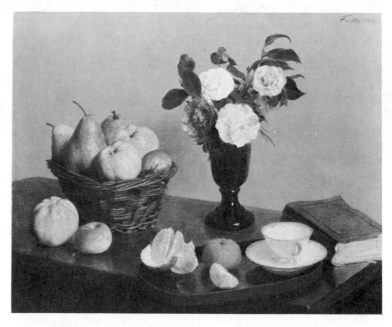

National Gallery of Art, Washington, D.C.

FIG. 42.—HENRI FANTIN-LATOUR, "STILL LIFE," 1866 (24⅜ × 29½ IN.)

AN APPROACH TO THE VISUAL ARTS

1. AN ANALYSIS OF THE WORK OF ART

"What is it?" or "What is it about?" we hear people asking in the picture galleries. No matter how "advanced" our views, the subject matter of a painting or a piece of sculpture always in some measure engages our attention, even though it is only slightly suggested. In fact, too often it is with the recognition of the subject matter that our consideration of the work stops. Although to stop there would be regrettable, the question "What is it?" is not necessarily an impertinent one, since the recognition of objects and incidents is usually an important ingredient in the artistic experience. Much history of art is concerned with the reclarification of subject matter that has become obscure with time. But such an understanding remains only one ingredient; it is not sufficient in itself to characterize the particular quality of a work of art. If it were, a verbal description could be the exact equivalent of a painting. Clearly there are other forces in action, affecting our experience and contributing to the specific meaning of the work. These forces are visual and belong appropriately to the visual arts. But how can the visual aspect of a painting in itself have meaning? This is the basic question for discussion in this chapter.

To keep from confusing what we normally call the subject matter of a work—the identifiable objects, incidents, or suggested outside experiences that we recognize—with the more complete aspect, taking as it were, the part for the whole, it might be useful to adopt the term "expressive content" to describe that unique fusion of subject matter and specific visual form which characterizes the particular work of art. "Subject matter," then, would be the objects and incidents represented; "expressive content" would refer to the combined effect of subject mat-

ter and visual form. This rather complicated relationship might become clearer were we to compare two paintings of precisely the same subject matter, even nominally of the same arrangement, which yet provide very different experiences; two paintings which have, in other words, the same subject matter but very different expressive contents.

"The Crucifixion with Saints" (Plate I), painted by the Italian artist Perugino late in the fifteenth century, presents a subject that is hardly new to us. The very mention of the title is sufficient to evoke many feelings based on past representations we have seen or on general attitudes toward the event itself. But Perugino's painting does not simply pose a subject to which can be attached any number of different emotional connotations; it would seem to quell the possible anguish and effects of suffering which might be associated with the scene and to establish a serenity and calm, a complete relaxation of the emotional and physical forces which might be expected to operate in connection with such a subject. Perugino has at once presented a subject and a statement about it. He has made us feel in a particular way about the Crucifixion, in a way we may not before have considered. Instead of being just the repetition of a familiar subject, the painting becomes, then, the basis of a new experience. Since the particular character of this new experience seems not to be the inevitable product of the subject, it behooves us, if we wish to discuss the peculiar power of the painting, to discover on what it depends: what produces the effect of calm, of limpid clarity, an atmosphere in which contemplation takes the place of physical violence. For this we must look to the visual forms of the painting itself.

So instantaneously does a painting seem to produce its effect that it is difficult to separate the steps by which the effect is achieved, and it must be admitted that such a separation is an arbitrary one. Nonetheless, it may lead us past the simple level of subject-matter identification to the particular character we associate with this painting, a character inseparable from our visual experience.

To begin on quite a literal level, this painting shows us, in a landscape that seems to extend at measured pace directly into depth, two figures standing on either side of the Cross upon which is fixed the figure of Christ. The vista seems calm, progressing through the repetition of gently curved horizontal lines suggesting a series of planes which overlap and repeat each other. In contrast, the compact, vertical forms of the figures seem somewhat isolated. We look from the figure of St. John on the right, to Christ, to the Virgin, and back again, and

yet have little feeling that these persons could make physical contact with one
another. Each part of the painting, landscape as well as figures, seems to take
its place in a fixed harmony, and a sense of stately measure results.

But before considering this relationship further, study for a moment the color
environment of which these forms are part. The number of hues employed in the
work is small and the eye quickly accepts the simplicity of their relationship.
It would be difficult to say whether the painting seems warm or cool in tone,
tending toward red or toward blue. The hues of blue and yellow appear to be
almost equal in quantity, although the yellow is far less vivid than it appears in
the solar spectrum: it is low in *saturation*, to use a term defined in chapter ii. As

a kind of intermediate color there is a bit of green which, containing both yellow
and blue, serves as a buffer between them. But of far greater power in holding
our attention than this intermediary green is the vivid red robe of the right figure,
St. John. Because of the nature of the hue and its high saturation, it seems equal
in importance to the blue and yellow. Red, blue, and yellow, subtly modulated
in value but distinct and uncomplicated as hues, achieve in the painting a kind
of equilibrium. Both the distinctness of the hues and the effect of balance may be
understood by studying the chart on page 70, which illustrates the fact that these
colors, called primaries, contain no part of each other and as a group represent a
balance of the entire spectrum. That colors provoke a direct emotional response
we constantly bear witness to in everyday speech: we see red, feel blue, and
speak of a dark character. Had Perugino caused his red to dominate over the
other hues so that it might seem to characterize the entire atmosphere—and a
very warm atmosphere it would seem—our reaction to the painting would be

very different. Instead there is an equilibrium of hues just as there is a marked clarity in the distinction of one hue from another, and this equilibrium and clarity are part of our experience of the painting.

Color, however, does more than simply characterize generally the emotional climate of the work. The hues occur in different relationships, sometimes red next to yellow, sometimes red next to blue, and in the background there is a kind of sequence ranging from yellow through green into blue. These relationships are made more complex and varied, by the modification of the hues in light and dark, that is, in *value*, and in saturation. Note, for example, the difference in blue between the sky, the tunic of St. John, and the robe of the Virgin. Cover for a moment the red robe of St. John with a piece of dark paper. Not only is the key of the painting basically changed, but the figures no longer bear the same relation to each other. Instead of our eye's going first to the figure of St. John and then rising to the figure of Christ, we seize at once upon the figure of Christ which pushes forward, losing all contact with the lower part of the painting. This is not just a compositional variation but a dramatic change in the way we feel about the painting, in its expressive content. Further, note the distribution of blue and yellow. The blue of the sky is carried through the lower portion of the painting in the tunic of St. John, in which it is slightly changed, and in the robe of the Virgin, in which it is very low in value and saturation. The yellow follows a more complex scheme. In the landscape it is broken up into contrasting areas of light and dark that become less marked as the yellow fuses with the green to merge imperceptibly into the blue. But this complexity prepares us for the dramatic appearance above of Christ, in whose body the yellow is freed to contrast simply and eloquently with the rival blue.

From this kind of study we might draw some general conclusions. Our eye tends to relate similar colors. Further, strong contrasts, whether of hue or of value, tend to attract our attention immediately, while gradual changes seem to lead us progressively from one step to the next. In this way our eye seems to move about the painting from color to color, from points of greater to points of lesser contrast or through marked sequences, following a pattern which may vary with regard to point of origin or concentration but not in expressive character.

The nature of this pattern, sensed as we shift our attention from one part of the painting to another, should be considered with care since, as in our gestures,

much feeling can be conveyed in the experience of movement. As we noted, our attention unites chiefly three points: the figures of the Virgin and St. John and the figure of Christ. Were we to diagram this relationship it might look like this:

How tremendously extended the vertical movement seems. While the Cross divides the painting into halves that are about equal in their attraction of color and contrast, affording the measured effect of symmetry, the vertical movement is so insistent that we cannot linger for any time on the horizontals of the landscape which cut across the painting and attempt to lure us plane by plane into depth. Yet these horizontals, especially the starkly defined bar of the Cross with the help of the contrasting inscription above the head of Christ, hold the vertical movement in check so that again we sense equilibrium rather than a dynamic continuity of force. The importance to this aspect of the organization the tiny inscription assumes by virtue of its value-contrast and shape can be tested by covering it with a piece of dark paper. That so much should depend on so small an element is indicative of the delicacy of balance which distinguishes this painting, a delicacy encouraging us to compare part with part and enjoy the justness of proportion. To a large extent, the relationships we have just observed are dependent on our perception of line, that is, the continuity of direction. Each figure seems to contain within itself a vertical line contrasting with the horizontal line of landscape and other elements. Moreover, diagonal lines, implied by our shift in attention rather than being explicit in any form, seem to go from the head of St. John to that of Christ, then down to Mary to become a part of a great elongated diamond shape completed by the suggestion of the two wedges at the foot of the Cross. It would be meaningless to point out such a shape except that

in this case its symmetry gives new reason for the sense of stability and balance we derive from the painting.

Our consciousness of a particular proportion, a sense of measure, which determines our movement through the large structural lines of the painting is dependent on a great many factors. For example, consider the shape of the painting as a whole. It is considerably taller than it is broad, though not so tall as to minimize completely the measurement of width. This is important, since the framing shape qualifies the effect of every form created within it. Suppose the construction lines remained the same but were contained within a different format:

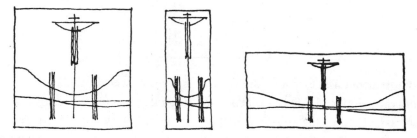

Each of these schemes would be quite possible, but the effect of the pictures, their expressive content, would be very different. Scale also plays its part. We quickly take as a module, as a kind of measure, some identifiable object or simply a strongly marked form, and judge the rest of the space in comparison with it. Not only are we brought close to or left far from the subject, but we can feel ourselves lost in a vast expanse or painfully crowded in a confining space.

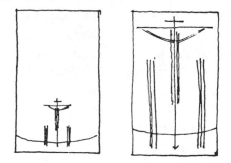

But to characterize the painting simply through its precise adjustment of vertical and horizontal structural lines within the determined format would be to ignore much of its particular effect. Although the figure of St. John may count

roughly as a vertical movement with regard to the whole, it embodies in its contours and implied interior lines rhythmical movements that not only give character to the figure but bring it into a harmony with other forms in the picture. In the very simplest terms these might be seen as flattened, drawn-out curves which in themselves seem to produce the effect of slow, co-ordinated movement. Note how similar lines, sometimes depending on contrasting contours, sometimes seeming to be within the forms as a core, characterize also the figure of Christ. Since our eye is quick to relate like things, we sense the figures as existing together in a rhythmical harmony even though the figures do not lose their compactness as entities nor seem in themselves to move. Nor are these rhythms con-

fined to the figures. Examine the trees—for example the entwining branches of the one delicately silhouetted on the right which move in quiet undulation—the long smooth curve of the road and bridge, the repeated arcs of the hills, all of which have a similarity of character, and you will see how far-reaching is the harmony that pervades this particular pictorial world.

We have made only a rudimentary beginning in analyzing in pictorial terms our experience of this picture, and of course we should not stop without studying the relationship of this panel to the two side panels that complement it (see Fig. 1). This painting is, in fact, the central portion of a three-panel altar piece, a triptych. The artist has had the problem of designing three compositions which are self-contained yet which join with each other to form a single whole. The complete work is reproduced in Figure 1. Note how the side panels modify and intensify various aspects we have mentioned of the central painting. It is well

to remember that a composition can be affected by forms outside itself, that two paintings viewed together, for example, may take on a different aspect than when viewed separately.

But before we complete this study it might be useful to test our assumptions and our procedure thus far by looking at another painting of exactly the same subject as our central panel.

Plate II reproduces another "Crucifixion," painted by the Italian artist Carlo Crivelli, also late in the fifteenth century. The subject matter is identical with Perugino's painting: Christ is shown on the Cross between St. John and the Virgin; the rocky landscape, the towered building, and the sea in the background are all familiar to us. Only the symbolic skull at the foot of the Cross has been added. But how different is our response to the painting. Here is no rest, no calm or contemplation. Instead we take upon ourselves the anguish and physical hurt which seem to motivate the actions of the figures. And nowhere is there escape, no point on which our attention can fix itself to bring order to our excited emotions. Yet the raw structure of the painting is the same as in the Perugino: two figures and the crucified Christ arranged traditionally in symmetrical fashion. On what, then, does this tremendous difference depend?

We have used the term color environment or color key, and much of the effect of clarity and balance in the Perugino depended on it. What is the color key of this? It is difficult even to name the colors used. For one thing, hues seem to combine with one another in many areas, as in the background that seems to modulate from yellow to green and yellow to red, or in Mary's cape where the blue emerges in places with green and elsewhere itself moves toward red. As a result we are less conscious of defined color shapes than in the other painting. Furthermore, the hues are hard to describe; they seem to be "in-between" hues: the cloak of St. John is not quite violet yet not quite red. Characteristic of its intermediate nature, each hue is mixed with at least one other hue in the painting. Again in the cloak of St. John, even the red-violet is reduced in saturation with yellow to bring it into accord with the green and yellow of his other garments; only the white, unrivaled by vivid, saturated hues, makes a sharp contrast. While no hue dominates this painting any more than it did the work of Perugino, there is not the effect of a color equilibrium existing between well-defined entities. Rather there is the impression of slightly distinguishable color notes rising above a general tone. Both the nature of the hues themselves and the fact that al-

most all are used in low saturation contribute to this effect of a somber and minor harmony.

There is no one strong color note here to start the action as in the Perugino, nor one sharp value-contrast. In fact, value-contrasts of almost equal attraction are dispersed throughout so that our eye seems to move quickly and constantly over the entire painting. Unlike the other work, where details are massed and there are large restful, unbroken areas, the whole surface is broken up by the scattered knotty clouds (note how they are organized in the Perugino), the sharply contrasting plants, and the harshly defined stones—an agitated surface which enters into the excitement of the moment. Yet within this general environment

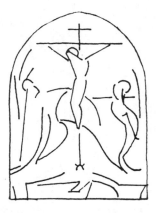

there is a positive path of movement that can be roughly suggested in a pattern of lines. There are many differences between this pattern and the one we experience in the other painting of like subject. For one thing, a single line of motion may move through both figure and landscape, uniting the two in a continuously moving design. The rocks themselves twist and bend in anguish with St. John. The landscape does not proceed plane by plane into depth but seems upended by the road, which is less inclined to retreat into the distance than to enter into the swirling pattern of the picture plane, that is, the plane represented by the panel itself.

But the action that has created this pattern is more than continuous; it is rapid and violent. What produces this effect in a painting in which the figures themselves seem hardly to move? One clue comes from a study of the lines and shapes that build up the very forms of the objects. Take again as example the

figure of St. John. The vertical structure-line of the figure has little meaning with regard to the effect of the whole, because the diagonal lines of his cloak are so strong that they destroy all possible sense of a vertical compact mass. And consider the nature of the lines themselves. Every curve is flattened and broken so that the line seems to struggle to reach its destination. Furthermore, if we isolate the line of the cloak, we see that far from suggesting the balanced arc of a circle, it seems rather like the lash of a whip. And this eccentric line is repeated throughout, in the robe of the Virgin, in the rocks, and even in the body of Christ. How contrasting with this is our scheme of the St. John of Perugino. The

lines of the Perugino seem to wrap themselves together into a smooth-planed volume, while those of the Crivelli disperse into the air, denying any sense of discrete volumetric form.

There is another source of this effect—the particular use of light and dark. We noted that the distribution of color and contrasts of light and dark throughout the painting was of a very different character from that of Perugino's work. Now note how the light and shade on the figures relate to the character of this general light and dark. In the cloak of St. John by Perugino each fold has its light side and its dark, and the transition between the extremes of value is clearly defined and orderly. As a result we sense each fold as a continuous surface that we could follow with our hand as if touching a piece of smooth marble sculpture. In the Crivelli, however, each shadow is complicated with a further variety of light and shade, and the larger patterns are broken into smaller and yet smaller

designs. The surface is far too complex to invite the stroke of our hand but, defying exact definition, seems to be in continuous action.

Carried away by the furious movements and knotty rhythms which, together with the strange minor color harmony, seem to characterize this painting, we have overlooked an important factor that is primary in any work of art: the proportional relationship of parts. In the first place, what is the nature of the format? Compared to the Perugino, this painting in its arched frame seems broad to the point of squatness, an effect intensified by the fact that the ground plane, the plane upon which the figures seem to stand, is elevated through the suggestion

of the clifflike break in the foreground. A similar proportion of width to height pervades the Cross itself, which does not loom above us as does the slender, graceful Cross of Perugino, but remains transfixed, massive and solid, in the center of the painting. Even the plaque above the head of Christ conforms to this different proportional scheme. Nowhere do we have the contrast between length and width which contributes much to the grace and delicacy of the Perugino; the length measurements seem less long, the widths less narrow. In consequence we are more conscious of the surface than we are of the direction implied by the shape. And we have seen how important that surface is in creating the effect of the Crivelli.

A similar proportional feeling dominates both the relationship between figure and figure and between the parts of the figures themselves. Consider, for example, the area St. John inhabits marked off clearly as a rectangle by the arms of the Cross. In the Perugino, the shape is almost three and one-half times as high as it is broad, and the slim vertical figure of St. John occupies only the lower half. We

see, then, the solid form against a vast expanse of void which in itself contributes to our feeling. But in the Crivelli the shape is only a little more than twice as high as it is broad, and the figure of St. John, much larger in scale and irregular in contour, is placed close to the center. Here we do not sense the relationship

between void and solid, nor do we experience the attenuated vertical movement of the Perugino. And look at the figures themselves. Even the bodily proportions contribute. The head of Perugino's St. John relates to his height in the ratio of 1:8½, again a marked contrast in proportion between small and large. In Crivelli's St. John the relationship is 1:7, something less than average human proportion. This would suggest that in a work of art the proportions of nature are subservient to the expressive relationships on which the artistic content depends. Proportion, like line and color, is determined in a work not by an external standard but by the expressive part it plays.

In the foregoing paragraphs we have discussed many features that seem inseparable from our experience of these two very different paintings; yet, although we have been able to distinguish the two experiences, we have not come very close to defining the qualities which make the paintings unique and compelling works of art. Even if we were to continue to analyze in this or in some other way for many more pages, some quality would still elude us. Some of us might be discouraged at this lack of finality; some might feel that, if a sure conclusion cannot be reached, the analysis is not worth pursuing. We should remind ourselves that the very capacity of an effective work to elude definition gives it power to live in our experience. And the analysis serves to broaden our experience by refining our perception of the individual work, leading us toward the definition of quality that can be completed only within the depths of our personal understanding.

In describing the difference in effect, in expressive pictorial content, of these two paintings, we have used a number of terms to describe the material elements which seemed inseparable from our experience: *color*, both as establishing a general key and as setting up a relationship of parts; *line*, both as creating a sense of structure and as embodying movement and character; *light and dark*, which created expressive forms and patterns at the same time it suggested the character of volumes through light and shade; the sense of *volume* itself and what might be called *mass* as contrasted with space; and the concept of *plane*, which was necessary in discussing the organization of space, both in depth and in a two-dimensional pattern. Towering over all these individual elements was the way they were put together, the *composition*, how part related to part and to the whole: composition not as an arbitrary scheme of organization but as a dominant contributor to the expressive content of the painting. It should be pointed out that had we chosen other paintings, these and other elements would, of course, be used quite differently, and we might have reacted quite differently to them. In this respect, each painting must be regarded as a new experience, and the analysis of its particular formal aspect simply as a means of characterizing its full expressive content.

Are these terms and procedures applicable also to experiences of other visual arts? Reproduced in Figure 2 is a photograph of a work created by the French sculptor Auguste Rodin in the 1860's. Try to look beyond the artificial photo-

graphic frame and see it as an actually existing object. The figure seems to struggle up into space, reaching out into the surrounding world. It is a melancholy struggle, a struggle of longing, which we sense as our own. As in the paint-

ings, this movement can be described in terms of lines which we apprehend as underlying the forms, lines which seem to cross each other in space, twisting about in such a way as to make us particularly aware of their actual three-dimensional existence. But this movement is not one great uninterrupted sweep; it does not free us to expand airily into space. Nor does it seem the movement of smoothly interacting muscles as in a gymnastic exercise. In fact, the sense of struggle seems to arise in part from the effort of the implied interior movement to free itself from the complex mass of material. This complexity, which keeps our attention somehow tied within the figure, we can describe with the help of some of the terms we have used before.

Note what part light and dark play. The polished surface is constantly interrupted by sharp ridges which catch the light, contrasting markedly with the shadowed concavities. These lights and darks become in themselves lines and shapes of broken, agitated character with much the same rhythm as the varied and undulating lines of contour. Because of this activity of contour and surface we have little sense of compact, defined volumes. Instead we move in and out through the forms, for all these ridges and contours, although they do not necessarily relate to specific anatomical features, seem to originate well within the mass.

Contrast these effects with those produced by the sculpture by Max Bill (Fig. 3). To be sure, we do not have a human figure in motion, but can the feeling of movement be resisted any more than our eye can fail to pursue the flowing lines of a streamlined car? There is no sense of struggle in this movement. Our attention is drawn swiftly through space, projected boldly into void, only to be brought back to recognize a pattern of equilibrium, delicately but surely established. And nothing conflicts with this action. Instead, every element speeds it on its way. The sequential gradations of light and dark on the smoothly polished surface create a sense of continuity of plane consistent with the fluid rhythms of the contours. The function of plane, which in a sense is the extension in breadth of the element we have called line, is important. Because of its continuity we see the various movements as modulations of a single surface: expansion and variety within a readily perceived unity. The plane contributes, moreover, along with the design of the path of movement itself, to another quality of the work quite different from the Rodin. Note the spaces between the planes, between the solid forms. They form shapes sympathetic in character to the rhythms we have spoken

of. But more than shapes they suggest volumes bounded by the planes and as expressive as the planes themselves. Yet it is characteristic of these volumes that, as we move around the work, they defy exact definition although they hold our attention within the balanced form. Our attention does not remain entangled with the solid members as in the Rodin but moves instead between related solids and voids. The consciousness of space, so differently displayed in these two works, might in some respects be considered related to such compositional means as we have already studied in the paintings. Although a work of sculpture is not usually contained within a frame, we are often made aware of an encompassing volume in which it seems to exist and which gives particular meaning to both solids and voids. Sometimes this volume seems defined and enclosed like a rigid block; in other works, as suggested by the Rodin, it is indefinite and expanding yet nonetheless present.

Rodin called his sculpture "The Prodigal Son." When we know the title our feelings about the work are rather confirmed than changed. It was not necessary, moreover, to know it to experience the emotional content, any more than it was necessary to examine the expression on the man's face. Max Bill called his work simply "Tripartite Unity" without attempting to define the ramifications which that unity and particular sense of equilibrium might have in our experience.

A word should be said about color, which plays its part in sculpture as well as in painting. The sculpture of Rodin is in bronze of a warm dark tone; that of Bill has the cold silvery glint of chrome-nickel steel. These colors are not a matter of chance but, like the materials themselves, were considered as expressive elements in the creation of the work. Try to imagine the hues of the two sculptures reversed. Our entire reaction would change: the Bill would probably seem heavy and plodding, while the Rodin would glitter superficially and the important depth and warmth of the surface shadows would be lost.

Consider now views of two country houses (Figs. 4 and 5): the Villa Capra by Andrea Palladio and the John Pew House by Frank Lloyd Wright. They were built in different climates some four hundred years apart and give evidence of different social attitudes, different approaches to construction, and many other causal factors. But our immediate interest is to discover how we can describe the great difference in our experience of the two buildings as they exist immediately before us.

It is tempting to say that one is very formal while the other is casual and in-

formal, but on what does such a distinction depend? Each, after all, was designed
with deliberation and forethought. The fact that both buildings are composed
chiefly in terms of planes arranged in parallel or at right angles to each other
seems almost too obvious to mention; yet note the proportions of these planes.
Most of those in the house by Wright are very long and narrow and create a
strong horizontal direction of movement. In those of Palladio's villa the two di-

mensions are more nearly equal; our attention is somewhat stabilized between
the horizontal and the vertical; we are more conscious of the defined surface than
of the direction the plane implies. And notice that in both buildings these pro-
portional tendencies are seen also in smaller parts like windows and doors. It is
impossible also to overlook the part played by light and dark in making some of
these shapes more important, more attractive, than others. This leads us to the
fact that these distinctions in proportion do not take us very far unless we con-

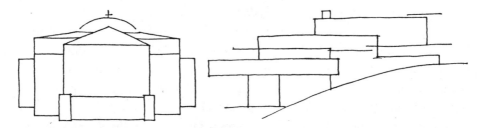

sider the experience of moving from part to part or from part to the whole: in
other words, the character of the composition.

To clarify the differences of these organizations of planes as they appear in our
views of the buildings, we might make simple diagrams. It is at once suggested
that the formal dignity of Palladio's villa is dependent not only on the self-
contained shapes but on their participation in a scheme of strict symmetry in
which every part bears a fixed and readily perceptible relationship to every other

part. A vertical axis is suggested in the very center of the façade to which all parts seem to make reference, repeating on either side exactly the same shapes and forms. Not only this, but the planes seem to be only the foreparts of simple cubic volumes which unite around a clearly defined axis in the center of the building. An examination of the scheme underlying the plan bears out this consistency of order.

The organization of the Wright house is, however, much more difficult to define. The horizontal movement is continued throughout by the overlapping planes; yet somehow these expanding parts are held together in a unified whole. There is no simple geometric shape to bound the assembled forms—in fact it is

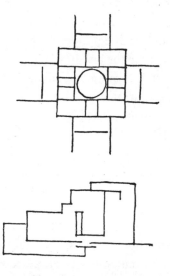

difficult to conceive of the profile of the house by itself—but somewhere within the life of these moving forms we recognize a center that seems to unify them. This is made the more complicated by the fact that these planes seem to relate also to volumes which in turn bound other volumes, as for example the deep space between the overhanging eaves and the balcony. Consequently our "center" seems to lie within the complex of these interlocking volumes. But much as in the Bill sculpture, this center of order can be experienced through the interplay of forms yet cannot be specifically defined. Our eye continues to move and search, seeking to experience to the utmost the elusive order existing within constant change. In Palladio the pleasure derives not from a sense of expansion and

change but in the justness of the harmonies and the completeness of the order in which we are invited to participate.

Compare the plans of the two buildings with the façades and you will see that there is an internal relationship that would strongly affect our experience while walking around or through the spaces of the buildings. But the special nature of such experience will be discussed later. Here we must catch up two important elements we have neglected: *texture* and *color*. They are most assertive in the house by Wright. Not only does the color of the rough stones make a pleasing contrast with the unpainted wood and unite happily with the rustic landscape, but, confined largely to areas which are vertical and supporting, the contrasting stones make more prominent the smooth horizontal planes that, moving freely into space, contribute most to the character of the building. The nature of this rich variety which demands our attention contributes much to the effect of informal intimacy we first noted in the building. Equally important to the effect of clarity and measure characteristic of the Palladian villa are the *uniform* coloring, broken only by the confined areas of light-and-dark pattern, and the smooth surfaces of the well-defined planes. The nicety of the regular and ordered composition depends on this polished smoothness.

Our terms and our method have proved useful in describing the experience of a variety of works ranging widely in time, in medium, and in character. In discussing the architecture both planes and textures seemed more significant than in the paintings; but had we chosen other examples, the relative importance of these elements might have been quite changed. The rough and smooth textures of paint are often of primary importance as, for example, in many paintings of Rembrandt; whereas linear continuity sometimes dominates our attention in looking at a building. But in all these works meaning became apparent only when these varied elements were brought together and considered in terms of the total experience. The various sketches throughout the text, while they may suggest the characteristics of parts, could never stand for the work itself, which, once we enter into it, seems in its complexity constantly to offer something new, some new relationship, some refinement of experience we overlooked on our first view.

2. COLOR AND PERSPECTIVE

COLOR TERMINOLOGY

In expressing our ideas about a work of art the description of color often presents a particularly difficult problem. Whereas forms can be measured and proportional schemes mathematically described, the complex nature of color is such as to encourage vague generalities and loosely comparative statements. Often these statements reveal, moreover, that color has been taken too readily for granted, simply as a handily descriptive aspect of things. All this is unfortunate, since, as we have seen, color can play a decisive role in the experience of a work of art. As a help both to sharpen our awareness of the experience and to describe it with some clarity, a well-defined color terminology is important.

Over the past two centuries we have learned much about the sensation of color, about the physical principles underlying its production, color mixture, the relativity of color perception under changing lights and in different situations, etc. With greater knowledge, the use of color and its description have constantly changed. In the practice and theory of art, various sets of terms, agreeing generally in meaning, have been devised to describe what have come to be regarded as the three basic properties of color. Although the validity of the terms depends on their interrelationship, the sets have often been confusingly combined and scrambled, encouraging the very sort of vagueness they were devised to prevent. For clarity it is important that one set of terms be carefully defined and then used consistently.

In this book we have adopted the terms *hue*, *saturation*, and *value* to describe these three basic properties. Although such terms will not provide the attractive

overtones of popular labels such as "peach," "sky blue," or "flame," they offer the advantage of far greater specificity in distinguishing between one color or group of colors and another. Just what variety and how mature a specimen of fruit are we to take as the standard for that often referred to as the color "peach"?

Hue can be described as the property which gives color its name—blue, blue-green, red, etc.—the name, that is, by which it is distinguished from other colors in the visible spectrum. Neither white nor black nor the gradations between them have the property of hue; since white is the total reflection of all potential hues, while black, in theory, reflects none at all. For the sensation of hue it is necessary

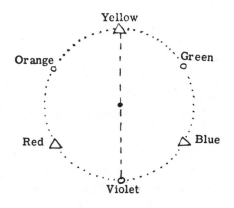

for some of the elements in what we normally look upon as "white" light (the elements that we can distinguish when a ray of sunlight is broken up by a prism) to be absorbed while others are reflected. The sensation of red, for example, is produced by the reflection of the red element in the spectrum and the relative absorption of all others.

For convenience of terminology the hues of the visible spectrum are often diagramed in a circle. The basis of the arrangement are the three colors that can be said to represent the entire spectrum because, as a group, they reflect all elements of the spectrum and from them, in theory, all other colors can be derived. In the mixing of pigments these three *primary colors* are red, yellow, and blue. They are basic in the sense that none of them can be mixed, and no one contains elements of another. Between the primary colors on the circle are placed the *secondary colors:* orange, green, and violet, being mixtures, as their position indi-

cates, of the adjacent hues. An indefinite number of intermediate hues also could be added, describable as yellow-green, red-orange, etc.

Three or more separate colors, however, are not necessary in order for the entire spectrum to be represented. For example, since violet is a combination of red and blue, it lacks only yellow for the completion of the spectrum (if we think of the spectrum in terms of our primaries). Yellow is called, therefore, the *complement* of violet. The diagram emphasizes this relationship by placing complementary colors directly opposite each other at the extremities of the diameter of the circle.

In pigments, complementary colors mixed together will cancel each other out, creating a neutral tone of gray or black. For example, since red, in theory, represents the absorption of all hues other than red and green represents the reflection only of blue, green, and yellow and the absorption of all red, in a mixture of the two all hues would be absorbed and there would be none left to reflect. The result would thus be a neutral gray or black. The following diagrams illustrate this.

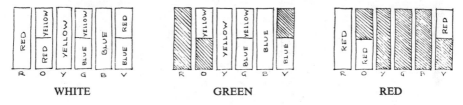

WHITE GREEN RED

In the first, which represents white, all hues are reflected equally. In the diagrams representing red and green the shaded portions indicate the elements absorbed. If the latter two diagrams are superimposed, it becomes clear that there are no elements remaining to reflect.

It has been necessary to qualify many of the statements made above by saying "in theory" because, while this is a useful way of thinking about color, it remains theoretical since absolutely pure hues do not exist in artists' pigments. What we call a red pigment may contain some yellow or some blue that will affect its mixture with another. For example, if a red that contains some yellow is mixed with a greenish blue, i.e., a blue which also contains some yellow, the result will not be pure violet but, because of the existence of a substantial quantity of the third primary, yellow, will be a color considerably reduced toward neutrality. Rather than trusting to labels, the artist must consider each pigment in terms of its actual color properties.

One last parenthetical note should be added for those interested in the complexity of the problem. The mixture of colored light works on quite a different principle from that of pigment. As one hue is added to another the result moves toward white, complete reflection, rather than toward black, complete absorption. The mixture of complements in light, therefore, results in a "whole" light containing the entire spectrum. But it must be borne in mind that the primary hues of light are differently designated, being variations of red, green, and blue. Light complements, then, are different from those of pigments.

Saturation refers to the relative purity of hues in comparison to their appearance in the spectrum. If the color seems to be the reflection in its most vivid form

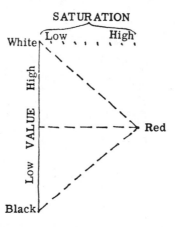

of the spectrum hue, it is said to be of *high saturation*. If, on the other hand, the quality of hue can scarcely be distinguished—if the color, that is, is nearly neutral—it is said to be of *low saturation*.

Value is a term for describing the relative lightness or darkness of a color. White represents the highest value, black the lowest. But every hue may be lightened almost to white or darkened almost to black, that is, *raised* or *lowered* in value.

All hues are not, at their highest saturation, of the same value. Yellow, for example, is much closer to white—higher in value—than is violet. If this characteristic value of a color is changed, the hue loses some of its vividness: it is lowered in saturation. If a full-saturation yellow, for example, were either lightened or darkened—moved closer either to white or to black—it would be less

vividly yellow; its saturation would be lower. It is, in fact, impossible to change the value of a color without in some way altering its saturation.

But altering the value is not the only way in which saturation can be changed. It is possible, for example, for a red to become less and less red—more nearly neutral—without becoming lighter or darker or changing its hue (moving toward orange or violet). It might simply move closer to gray. Thus a change in saturation may or may not be independent of a change in value.

The relationship between these two properties can be simply diagramed as on page 72. The value scale is represented by the vertical dimension, the saturation scale by the horizontal. The hue at its full saturation is located opposite the appropriate value on the value scale: red would be about halfway, yellow much closer to the top. A horizontal line drawn between the hue and its related value of gray represents the complete span of the saturation scale, from complete saturation to neutrality. Note that this range does not take the color either up toward white or down toward black on the value scale. But if the hue is moved toward white or toward black, raised or lowered in value, the diagonal line clearly demonstrates that it must change its position also on the horizontal scale of saturation.

PERSPECTIVE AND THE EXPERIENCE OF DEPTH IN PAINTING

Possibly because a consideration of depth, the most elusive spatial dimension, is in itself fascinating, the achievement of spatial effects in painting has often been accorded more respectful awe than it merits. Actually it is difficult to draw as few as three lines within a given frame without in some measure suggesting depth. The fact that an artist has created an effect of depth in a painting is far less important than what he has been able to make us feel about the depth. Technical systems and spatial schemes are significant to the artist only in so far as they help him to embody his meaning in the form.

There is a great variety in the spatial structure of paintings. Some paintings are created in such a way as to suggest a completely unified space seen at one time from a fixed point of view. Some others suggest space by shifting our attention from one area to the next without reference to one fixed point, providing a kind of accumulative experience involving time. It would be a thoughtless error to criticize the effect of one procedure by the rules of another.

During the fourteenth century many European painters, as their paintings indicate, shared a desire to discover a principle by which a painting could be organized to suggest a single unified space. Only in the fifteenth century, however, were the rules set down for the strict systems creating what we know as perspective. Interestingly, these rules were once looked upon as serving less the creation of illusion than the articulation of natural harmonic laws of perception. Perspective for many early painters, in other words, had a content of its own.

Traditionally there are two related systems of perspective: *linear perspective*, which is based on the relative diminution in the apparent size of objects as they are located at greater distance from the viewing point; and *aerial perspective*, which is based on the apparent change in color and distinctness of objects viewed at a distance.

Although complicated geometrical schemes have been devised for linear perspective, the general principle is simple. It depends principally on two conditions: the level of our eye when viewing a scene or object, which determines the "horizon," and our distance from the object. Note how the difference in eye level can change the effect of a composition.

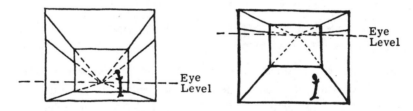

These diagrams illustrate a basic law of perspective, that parallel lines which lie in the same plane will seem to converge at a point on the horizon (at the eye level). This point is called the *vanishing point*. This is true whether we look into a space, such as a room, or at an object placed at an angle, such as a building seen from the corner.

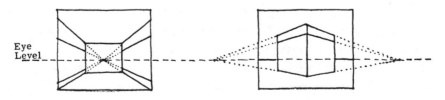

Our distance from an object seen at an angle determines where the vanishing points lie on the horizon.

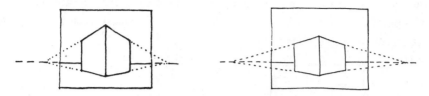

The vanishing point often exerts a kind of pull in a composition, constituting a positive force in the pictorial design even when it lies outside of the frame of the painting. Thus in its own right, perspective can create a very active or a tranquil space, supporting an effect of equilibrium or establishing a tension of unrest.

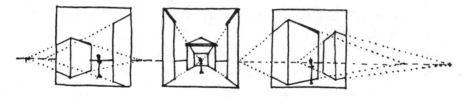

The general principles of perspective do not bind the painter by hard and fast rules but, like all other elements of potential expressiveness, are subject to the pictorial idea of the artist. Consider how different, for example, travel between the two blocks of buildings would seem in the diagrams. In the first diagram all objects are related to a single view point. We see the space all at one time, viewing the foreground against the receding background. In the second, how-

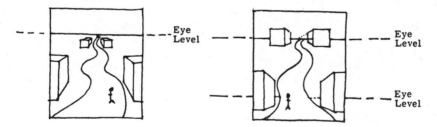

ever, where our view point is divided, we seem equally present in the distance and in the foreground; we travel constantly between the two, seeing each from its own view point. To see this second drawing as a simple spatial unity would be difficult because we tend intuitively to concentrate on one area at a time.

This shift in view point is both an old and a new device. At times it can be quite dramatic. Note how different these two city squares appear. In the diagram at the right, while the square itself is seen from a high eye level, the arch is viewed from a position close to its base. The arch assumes, in consequence, a greater importance and a very different character.

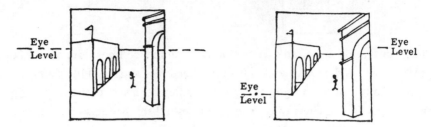

In these pairs of examples it is not a matter of one being correct and another incorrect. As we have said, perspective is a tool of the artist to be used as he sees fit. It is only when some forms intrude as inconsistent with the evident content of the work that the technical device can be said to err.

3. SOME DISTINCTIVE CHARACTERISTICS WITHIN THE VISUAL ARTS

The first chapter considered characteristics that all the visual arts seem to hold in common. Basic to the discussion was the realization that the expressive content of a work is embodied in its very forms; that differences in color, shape, texture, and line and the way these and other elements are combined are not mere technical differences in art but mark differences in expression and feeling. But form in sculpture is in many ways different from form in painting or form in architecture. It is produced through different processes and experienced in quite distinct ways. In fact, if our assumptions concerning form and content are valid, we must assume that each new material and each new technique present possibilities for fresh experiences and distinct expressions. A study of varied artistic media—from etching to architecture—becomes, then, a means of expanding our artistic experience, of discovering those special pleasures that each of the arts affords.

In this section drawing and painting, graphic arts, sculpture, and architecture are treated separately with attention to some of those aspects peculiar to each. Such a study encourages us to consider, in discussing the ultimate effect of a work, just what part the artist's choice of material or method has played in establishing this particular communication of experience. It is impossible to apprehend an artistic idea without recourse to some physical medium, and the artist's choice of medium becomes a part of his creative activity. The artist's decision to draw in ink or chalk or carve in wood or marble is of significance to the eventual form he evolves and, in consequence, to the experience we as participants share.

An appreciation of the particular nature of these experiences may be enhanced by a knowledge of the actual processes involved and by a recognition of the expressiveness artists have found in some established materials and methods.

As with the formal elements discussed in the preceding chapter, it must always be remembered that simply to recognize the medium or technique of a work is in itself of little relevance to anyone but an archivist or dealer. It becomes of significance only when a knowledge of the technique helps in describing the particular artistic character of the work. It is not, in other words, the end of study but is simply one more rather useful means for the illumination of experience.

DRAWING AND PAINTING

Because of the directness of their execution drawings often give a particularly clear indication of an artist's vision, his aims and formal means. Often in a drawing we feel that we have made a close contact with the artist himself, as if we were present at the moment the artistic idea was first formulated. Possibly, also, because of this directness and the simplicity of means, we are especially conscious, in drawing, of the medium employed. We very quickly note and accept the medium with its inherent qualities, without expecting it to be lost in an illusion of space or imitated texture. For this very reason the artist's choice of material becomes of particular importance.

In the drawing he made of the engineer Mallet in Rome in 1809 (Fig. 6), the French painter Jean Auguste Dominique Ingres chose to use a sharp, hard pencil on smooth paper. This is not a flexible medium, but a consideration of the drawing makes clear why Ingres chose it. Despite the bulk of M. Mallet in his heavy greatcoat, there is a lightness and refinement to the drawing. Probably two qualities most contribute to this: the character of the contours and the precision with which each shape is defined and related to every other shape. Note, for example, the successive contours of the hem of the coat moving from right to left—how the subtly defined S-curve is repeated with slight variation, or how the series of lines in the cape over his left arm and in the collar of the coat rhythmically repeat a similar movement. Certainly much of the character of these rhythms is dependent on the precision and delicacy of the lines themselves, on the sharp and unequivocal marks of the hard pencil which reveal the remarkable judgment and control necessary to the realization of Ingres's artistic vision.

How different the character of the drawing would be had Ingres chosen the

soft pencil and charcoal used by Honoré Daumier for his drawing entitled "Fright" (Fig. 7). Daumier obviously had a different end in mind. His is a nervous, exciting drawing in which movement runs riot in a chaos of agitated lines. Each line seems not the product of reflection and forethought as in the Ingres but the result of a spontaneous gesture, and Daumier has selected a material that will record unresistingly each pulsating movement of the hand. He has, moreover, selected a rough paper that breaks up the line even more, causing it to sparkle and vibrate, suggesting rather than completing the forms. Nor is the line uniform in weight, as that of Ingres tends to be, but ranges from heavy and thick to light and thin, causing our eye to jump erratically from part to part, rather than smoothly and continuously. It would be quite as impossible to imagine Daumier achieving his effect of terror and shock with the means of Ingres as it would to conceive of Ingres struggling for his formal definition with the soft, responsive materials of Daumier.

The difference, of course, is not simply one of materials but rather is dependent on what qualities of the material the artist consciously or unconsciously exploits for his own purposes. Both Ingres and Daumier, for example, used oil paint for their paintings; yet what could be more different than Ingres's painting of "Oedipus and the Sphinx" (Fig. 8), completed in Rome just a year before his drawing of the engineer, and Daumier's "Advice to a Young Artist" (Fig. 9). Not only did Ingres choose a subject as remote as Daumier's was present and immediate, but he used his medium in an entirely different way.

As you will learn from chapter iv, oil paint is a flexible medium subject to many different uses. It can be applied transparently or opaquely, in thin layers or in thick strokes. The surface may be smooth, with every brush stroke blended, or rough, with each stroke in bold relief. Ingres has used his oil paint with the same studied deliberation as his pencil. Within the forms the lights blend so easily into the darks that the material contours are undisturbed and are free to carry on the same suave linear continuity we noted in the pencil drawing. Beyond the simply related lines, we can appreciate the subtle transitions of value and the smooth flowing surface that seem consistent with the rather remote air of quiet and contemplation.

Daumier, on the other hand, does not hide a single stroke. Sometimes dragging thin transparent paint, sometimes piling up paint opaquely, he creates a surface as agitated and pulsating with life as the line of his drawing. The distinction be-

tween light shapes and dark shapes is strengthened by these contrasts of transparent and opaque paint. The warm translucent shadows invite the eye to explore a limitless depth. Never does a contour or surface remain a fixed thing; it seems to move and grow. The hand of the artist is revealed in every line and shape.

Daumier and Ingres in these paintings have used the same medium in very different ways, utilizing different characteristics for their own purposes. Ingres made use of the viscous blending quality of oil paint, Daumier its body and range of transparency.

Had Ingres wished to emphasize principally clarity of contour and not also the soft blending of values, he might have chosen to paint in tempera, a medium the Sienese painter Simone Martini used some five centuries earlier for his "Annunciation" (Figs. 10 and 11), now in the Uffizi Galleries in Florence. The clear contours and precisely defined shapes to which the medium of tempera applied on a smooth ground is so admirably suited are essential to the effectiveness of Martini's design. Of course, Simone Martini did not have the same choice of medium as Ingres; there was not yet established a tradition of painting in oil—in fact, oil paint as an artistic medium was unknown. However, what Simone Martini had to say is so closely related to the way he said it, to the characteristics of the material at hand, that it is difficult to imagine his deriving any advantage from the use of a different medium. At certain points in history new media and new artistic forms have evolved at the same time, and one might be led into a discussion of whether the medium was developed from the need for expression or whether the expression was made possible by the invention of the medium. The question is an academic one. What is more important is the fact that, whether he chooses from a great range of media or works unquestioningly in traditionally prescribed material, the artist will tend to visualize the ultimate expressive form of his work in terms of the medium itself, so that characteristic aspects of the medium and artistic form are inseparably united.

There is one other aspect of painting that might justly be included in this discussion of technique and medium, since it too plays a part in the material formation of the work. That is the situation for which a painting is painted, how it initially was meant to be seen. The creation of paintings expressly to be hung in public galleries is a relatively recent tendency. Paintings have been created within the confines of miniatures whose tiny size demands close scrutiny and have filled

the walls and ceilings of rooms to overwhelm the senses by their encompassing breadth. Size is not an unimportant factor in the effect of a work. It has to do not only with the choice of medium but with our consciousness of the medium and of the way the work is done. The importance of this can be seen by greatly enlarging a reproduction of a small painting. What were hardly noticeable brush strokes become powerful slashes; the movements of fingers become the strokes of arms. Because of this the character of the painting is entirely changed. In a sense, it has become a different painting. This fact should be borne in mind when looking at books of reproductions, which often reduce to the same scale paintings of very different size. Then there is the question of the point from which the painting was meant to be seen, whether from above or below, from near or far. This is of especial importance with paintings created to relate to architecture. Because of these factors of specific material, of size, of placement, it is important to view whenever possible the original paintings; reproductions, no matter how accurate, may be useful but are in no way substitutes for the original works.

GRAPHIC ARTS

From their first appearance—which in Europe was not much before the fifteenth century—prints have been looked upon with particular fascination. Doubtless in the beginning this was in part occasioned by the novelty of a unique image that appeared in many copies. Quite aside from how astonishing this might seem to an age not yet accustomed to printing in general, this aspect of prints has remained an important element in the way they are regarded. Existing as it does in a family of more or less identical members—an edition— a print, for all its closeness to the artist during the process of creation, enjoys a degree of detachment as an object that is rarely accorded a painting or drawing. This sense of an objective existence persists even if only one print is made or known, because a print carries with it the implication that the artist has completed his work, judged it, and released the image to the impersonal realm of printing. Although the actual process of the final printing is not to be regarded lightly—it is still a part of the creative process—once the finished print emerges, the long step-by-step process by which it was created is hardly suggested. Instead it presents both to artist and viewer an integrated, self-contained image that seems to be embodied completely in the evident medium of the print itself.

When we look at most paintings or drawings, it is hard not to be conscious of how the artist worked on this particular piece of canvas or paper. Often, in fact, the freely brushed paint or the richly flowing line of India ink invites us to join the process as co-creators. Some works seem to remain in process, making us aware of the uniqueness of the object at the point of its coming into being. To be sure this is not always true; some paintings and drawings reach a degree of finish that effectively discourages our sense of manual participation. Nonetheless, we feel we are in the presence of a unique object that was subject to the hand of the artist down to its final visibly present stroke. In the case of the print, the creative process is divided into two phases, each of which involves the artist's developing ideas. The first is the preparation of the block, the plate, the stone or the stencil to be printed. Even when completed, the block or plate— regardless of how attractive as an object—is not the final work of art; the work is only half made until the printing takes place. Furthermore, it is a rare artist who can wait until the block is totally cut or the plate totally etched before he prints a proof to see how it is coming out. Characteristically as the print is developed the artist is constantly aware of the printed effect, and proofs are followed by modifications and then more proofs until that which is printed satisfies the artist's intentions. But no matter how protracted the process, once the work is complete the print is produced all at once or, for color, in a limited series of overprintings, so that the process most evident is likely to be not the preparation by the artist but the act of printing.

Quite probably the complexity of the mechanical intervention in printmaking between the initial impulse and the completed print has a decided effect on the artist, tempering his work rather more than do the processes of other media. No matter how spontaneously a wood block may be cut, the two-phase process of cutting and printing is bound to have an influence on the critical judgment of the artist. Moreover, the repeated printing of a spontaneous image grants the momentary act an authoritative permanence, a fact the artist does not overlook. For all the exacting demands of the process, there is something peculiarly satisfying—even to a degree mysterious—about the emergence of the first impression of a print which, somewhere along the line, seems to have taken on a character of its own. It is in the process itself that the artist discovers the magic of printmaking, and the dialogue between process and impulse produces

a result often quite distinct from what the same artist might produce in another medium.

As discussed in chapter iv, there are basically four processes for making prints: intaglio, relief, planographic, and stencil. Each method makes its own demands and offers its characteristic rewards. What the four terms refer to is how the ink or other printing medium is transferred from the matrix to a second surface, the procedure, of course, which makes a print a print. It is helpful to have a knowledge of the process when looking at a print, because each has its generic characteristics within which the specific expression of the print is formulated. To know how the forms were arrived at alerts one to their special qualities.

For example, the forms in the anonymous print depicting "The Agony in the Garden" (Fig. 12) are notably blocky, and the lines have a gaunt boniness that in no way suggests the fluidity of pen or brush. Furthermore, the whole composition seems to have been conceived of in terms of flat areas that have then been divided rather decoratively into parts. (The colored tones were filled in later by hand.) This early print is a woodcut, which means that the design was drawn on a smooth piece of wood and everything that was not to print was cut away with knives or gouges. The process was the same as that used in the earliest printed books, in which type and illustration were cut in the same block. As in the printing of type, the design on the block was the reverse of what appears on the print (to print YOU the block would have to be cut UOY). This reversal is true of all print processes except stencil and can have its importance since reversing a composition can materially change its effect. Most later printmakers took this into account, some did not. To return to our early woodcut, it is evident that the person who carved the block—it may or may not have been the artist who drew the design—has modified the drawing to conform to the way his tools cut into the block of wood, hence the forceful choppy lines. Since in a relief print (and a woodcut is a relief print because that part of the block in relief prints) the surface is inked and the areas to be left unprinted are cut away, it is understandable, too, why the cutter has unconsciously maintained a patterned unity within certain areas that was not likely to be as evident in the original drawing on the block. So the cutting became an interpretation in terms of the wood and knives, rather than just the copying of a drawing, and the

result bears a distinctive character unlike that produced in any other medium.

The effect of the woodcut process need not be so simple and crude as in our early example, although it must be admitted that the awkward honesty of the cutting in this case adds much to the effectiveness of the print. Even though the process is the same, Albrecht Dürer's woodcut of the identical subject (Fig. 13) is a brilliant example of masterful cutting in which few concessions have been made to the resistant material and the technical demands. The technical skill is especially remarkable when one remembers that the actual print is somewhat smaller than the reproduction. By the time of Dürer's print, some fifty years after the earlier example, skill in cutting the block had developed to a point at which it could contend with Dürer's precise and demanding draughtsmanship without losing the qualities of the artist's incisive line. Even so, Dürer was consciously making prints, not finished drawings, and conceived such compositions as this with a full knowledge of the wood block, its limitations and compositional possibilities. Whether he carved the blocks himself or saw to their exacting execution by a skilled craftsman, the medium formed a part of his creative thinking. For all of the technical difference between this and the earlier print, there are family similarities.

One notable aspect of a print such as that by Dürer, which at first glance may seem almost identical to an ink drawing, is the uniform blackness of the lines. Although they may be wider or narrower, they do not vary in their value or physically cross over one another. The reason, of course, is obvious. They were all printed from the same surface at the same time, thus reinforcing in their uniformity of tone the peculiar unity of the print. Occasionally in printing, artists, notably the Japanese, have actually blended colors on the block, but usually they have been content to ink blocks with a single continuous tone. If several colors are wanted, a separate block for each is normally used, and each color retains the uniform tone of its particular block.

Even the most skilled master at cutting wood blocks would be unable to catch the quality of line that gives Martin Schöngauer's print, also of "The Agony in the Garden" (Fig. 14), its silken elegance. The actual print is almost the exact size of the reproduction. The fine but surely drawn lines seem to begin and end in the air, moving as free agents with no allegiance to a patterned shape or single surface. And free agents they are because they reproduce directly the lines drawn by the hand of the artist. This is an intaglio print made by the

process of engraving, a technique explained in chapter iv. If one scratches or in any way indents the surface of a metal plate and then wipes over it with thick ink, the ink will tend to remain in the indentations even though the surface is wiped quite clean. Were the plate then to be covered with a slightly dampened paper and put through a press, the ink from the indentations would leave an accurate record of all of the scratches and indentations on the paper. This is the basis of all intaglio processes in which the lines or areas "cut in" (which is what intaglio means) print.

In the case of Schöngauer, one of the great early engravers (intaglio print-making began in the first half of the fifteenth century), the smooth metal plate was cut into by sharp, angular tools that, depending on the pressure of the hand, could cut either very fine or heavy grooves that eventually would print as fine or heavy lines. By altering the pressure a line might be produced that could swell or diminish gradually in width. The resistance of the metal may make abrupt changes in direction difficult, but it also helps to steady the hand in producing a smooth and regular line, more precise than one drawn with a pen on paper in which every pulsation of the hand is recorded. It is this superbly controlled, steady line that gives an engraving its peculiar finish, whether the line exists alone or is joined with other lines to create the effect of carefully modulated tones.

Although etching is another form of the intaglio process, it encourages effects far different from those admired in engraving. Since the artist does not cut directly into the metal but only into a wax coating (acid eats the lines into the metal), there is no reason for the line to be any more restrained than one drawn on paper. This is evident in Rembrandt's etching of "The Agony in the Garden" (Fig. 15), in which the lines are drawn with great freedom—in some places they seem actually sketchy—and have none of the exacting regularity characteristic of engraving. To create differences in the width of lines, the acid is allowed to remain in some areas for longer periods of time. Each line, then, has its uniform width and does not swell from thin to thick to thin as characteristic of engravings. (This is especially clear in the reproduction, which is somewhat larger than the actual print.) In fact the whole process, with its multiple stages of etching with acid and the stopping out of areas (blocking the effect of acid) and the possibility of direct changes to the plate by scratching with a point (drypoint) or sharpening lines with an engraving tool, encourages a kind of free exploration in achieving

effects quite foreign to the engraving tradition. And Rembrandt took full advantage of the many possibilities, producing state after state of some of his prints until he achieved the luminous darks and radiant lights that satisfied his expressive goals.

Without concerning ourselves with other techniques for making prints or going into the many possible variations within the processes we have discussed, it is apparent that although prints may be looked at together as a class, the variety of techniques and methods used by artists in making prints provides an extraordinary range and diversity of experience. The possibilities have not been lost on the modern artist. Beginning in the late nineteenth century, there was a succession of revivals of interest in various print media. By the 1950's, print-making had taken on new momentum among artists and was looked upon as a distinctive form of art. More and more artists were drawn to the medium either to devote their time principally to creating prints or to expanding through prints the expression developed previously in their painting. In the United States and elsewhere, centers of print craftsmen were established to aid the artist where skilled printers could collaborate with artists in producing technically complex and expressively effective prints. This collaboration between the crafts-man and the artist had a long tradition—reaching back at least as far as Dürer—but its expansion in modern times has had a telling effect on the nature of printmaking. Not only has it encouraged technical sophistication and allowed artists not primarily trained in printmaking to experiment boldly with graphic media, but it has stimulated production and aided in giving the print new stature in the world of art. Except when used for special purposes such as posters, prints traditionally have been modest in size, something to be looked at close at hand. The exquisite concentration of a small, meticulously executed print is a part of its fascination, drawing the viewer into itself in a way not usual for a painting hanging on the wall. Modern prints, however, made often with the collaboration of craftsmen, have at times reached a size and boldness that allow them to hold their own on a gallery wall with the equal force of a painting.

Nonetheless, the print has retained its own qualities and, for the most part, is looked at under rather different circumstances than painting. Often kept in portfolios or protective boxes, a collection of prints invites initimate inspection. Even when framed for the wall, a print tends to draw the viewer to it, to en-courage an involvement in what seems to be the print process itself. Over many

centuries and through many changes, the world of the print has retained its special fascination.

SCULPTURE

It is obvious that a difference exists between works created by the painter or print-maker and those created by the sculptor. A painting and a statue are two different types of works of art. This distinction is so basic that it is made automatically—almost, it may seem, without thinking. Further, among works of sculpture equally basic distinctions can be made. One work may be of marble with all that implies of color and texture, another may be of wood. One may be seen as carved, another as cast. With training and experience, knowledge of these distinctions can be expanded and made more specific, permitting a more exact realization of the particular character of the work. But for these distinctions to be meaningful to our experience of the work of art, we must first understand the nature of the medium chosen by the artist; our previous experience with drawing, painting, and the graphic arts has revealed how closely the choice of material and technique is allied with the character of the work. Thus before considering the materials and techniques of sculpture, we must consider what has led to their selection for a particular work. The first question is why one man should choose to create a work of sculpture rather than, for example, a painting.

To answer this question we might well begin by considering what constitutes the difference that seems so obvious between painting and sculpture. What is the fundamental difference in the way the sculptor gives form to his ideas and feelings and the way of the painter? Broadly stated, it is simply that a sculptor finds it necessary and desirable to use an actual third dimension in the creation of his work of art. We may accept this statement as describing the distinction we have long made automatically between the works of the sculptor and the painter. But, although this may provide the basis for our distinguishing between the two, it is obvious that we need to determine this distinction more precisely, for we know that artists other than sculptors are also concerned with the third dimension. We have seen that the painter also considers space and depth as possible means of expression. Yet when we look at a painting in which these elements are forcefully expressed and compare it with a piece of sculpture, we are immediately aware of a difference, however difficult it may be for us to express our feelings about this difference.

In part our impression may be explained by the fact that when a painter works

in the third dimension his medium forces him to use illusion or suggestion. The sculptor is under no such restriction, for his medium is in itself third-dimensional. But this does not completely explain our feeling about the existence of the piece of sculpture compared with the painting; we feel that if we were to touch the piece of sculpture—which is a desire sculpture produces—we could grasp it and prove its dimensional existence. In fact, a piece of sculpture makes us very conscious of its spatial dimensions. But why should a piece of sculpture do this when many other objects which are three-dimensional do not?

A piece of sculpture seems to create an aura, an atmosphere in which it exists and in which every form seems particularly important, and this aura is dependent on a sensitive relationship between the solid forms of the work and the space around. The sculptor creates not only an object of a certain size and weight but also a space that we experience in a specific way. The space in which we see the sculpture is an inseparable part of the work itself. It is a reciprocal relationship, this interplay between the solid and space. Although initially the solid object created the space, in turn the created space acts upon the object, affecting its appearance. This becomes one of the most important factors for the artist who works with sculpture.

The nature of this relationship and its expressive power may be recognized more readily if we consider some of the possible treatments of space. Naturally, as there exist various types of three-dimensional objects, so there exist different experiences of space. However, we may distinguish two general treatments. These may be seen in comparing two such very different works as the seated Egyptian figure called "Ouah ab ra" (Fig. 16) and the "Mercury" of Giovanni da Bologna (Fig. 17). The Egyptian piece impresses us by its apparent solidity and compactness, holding our attention within the form; in contrast to the "Mercury" it has few protruding parts. The "Mercury" impresses us in quite an opposite fashion. To emphasize the difference between the two we might imagine what would occur if we were to ship these two pieces from one museum to another. The crate constructed around the Egyptian piece would contain very little empty space; the piece would fill the entire crate. However, a similar rectangular crate built around the "Mercury" would contain a great deal of empty space, and the statue with its explosive, outward movements so confined would seem unhappy indeed. The first work with its confining, inward forms, demanding little of the surrounding area, might be said to create a closed space; the much larger,

expanding, quality of space created by the second figure we might identify as open space.

The number and type of materials out of which a sculptor may create his work are many, and each presents particular qualities on which the artist may draw in giving expression to his initial concept. A few of the possible materials and their natures are considered in chapter iv. However, all the solid materials from which the sculptor may choose group themselves into two large divisions based on the manner of working they impose on the sculptor; basically the sculptor is given a choice between two possible ways of achieving his work. These two ways imply fundamentally opposite principles of creation that are largely responsible for the form of the final work. The sculptor may choose a material whose nature is such that he arrives at his desired form by removing areas from a given block, or he may choose one from which he builds his final form through the gradual addition of material. The choice of one of these fundamentally different methods of creating a piece of sculpture is governed by what the artist wishes to impart to his work. The effect of this choice can be seen by looking again at the Egyptian figure and the "Mercury." The Egyptian piece is an example of removing a part of the original material to arrive at the final form; the figure is carved from a block of stone. In contrast, the Renaissance piece was created by building up from a central core to the final form. The figure of Mercury was modeled by the sculptor in clay or wax before being cast in bronze. A part of the difference we observed earlier between the two figures is related to the difference in methods and materials the artists have chosen.

The Egyptian sculptor, cutting into a block of stone, has shaped and organized the parts of his work so that they produce a particular sense of order, a unique and expressive total form. The individual parts have been conceived of as planes which define the figure by creating a movement from one part to another, a movement that depends on our responding to each new change in direction until we have, in our observation, encompassed the entire form. In this process our sense of the third-dimensional aspect of the work is enforced and we become conscious of the work as a whole. The movement within the figure is very slight, and our impression is one of solidity, compactness, and immobility. Such qualities are also those of the stone itself, and we realize that by limiting the movement and keeping it totally within the figure the artist encourages us to associate the quality of the medium with the very character of the statue. We continue to sense

the block of stone from which this figure has been carved.

In creating his figure of Mercury, Giovanni da Bologna also relies on move-ment to relate the various parts of the piece and to help create the final impres-sion of the work. The movement directed by the sculptor through the arrange-ment of the various parts allows us to comprehend the piece as a whole. How-ever, in this statue the movement is active and rapid in contrast with the Egyptian figure. The sculptor's medium has encouraged him to create a free movement around the figure and out into the space in which the figure is seen. This space becomes an active part of the composition. We are conscious not only of the actual space displaced by the figure, as in the former piece, but also of the space seeming to emanate from the figure of Mercury. The importance of this expand-ing space for the statue may be illustrated if we imagine this figure placed in a shallow niche. Although it might fit physically, its rhythms would seem trun-cated, and it would suffer considerably as a work of art. The Egyptian sculpture might not demand so particular a space setting, but it would clearly suffer in assuming Mercury's place as the center piece of a splashing fountain.

The power of a piece of sculpture over an enormous amount of space and its ability to dictate its surroundings may be seen in examples of civic monuments in vast squares where the relationship between the monument and the surrounding architecture is of basic concern to the sculptor and of great importance in our impression of the piece. As the sculptor may order the movement within the statues, so he may also order the point of view from which the work is to be seen and the extent and character of the surrounding space.

ARCHITECTURE

Of all the visual arts, architecture poses probably the most difficult problems to one who would analyze the source of its character. A maxim for evaluating it has been repeated in slightly varying form for many centuries, dividing the judg-ment among three closely related points; these might be summarized as firmness, utility, and delight. Various periods have looked upon the interrelationship of these qualities in different ways, but the fact that "delight," although not the necessary product of firmness and utility, is nonetheless dependent on these qualities has generally been recognized. This fact in itself places architecture in quite a different category from the other arts we have discussed. But architecture is distinguished in other ways.

In the first chapter we looked at two buildings in much the same way as at painting and sculpture. We noted how important in our experience were shape and proportion, texture, color, and, above all, the relationship of parts. Had we gone further, we should have noticed other characteristics especially significant in architecture, characteristics that are equally important in determining how we see and come to appreciate a building.

Look again at the two buildings—the house by Frank Lloyd Wright and the villa by Andrea Palladio (Figs. 4 and 5). We noted that they seem to express two very different concepts of order, making us sense space in two quite different ways. Imagine the two buildings in various settings, with different approaches. It becomes clear that buildings rarely confine their influence within a frame but are likely, instead, to change the way we regard the entire surrounding area. For example:

One might say that the Palladio, by its positive statement of a clear proportional idea, becomes a kind of measure for the surrounding country without ever merging with the landscape. The house by Wright, on the other hand, moves into the surrounding space, seeming to mingle with the natural forms to become a part of the landscape itself.

With regard to the external appearance of the buildings, you will recall that when we compared the plan-schemes with the elevations, it became evident that the internal relationship of parts followed closely the same principle of organiza-

tion suggested by the exterior. Now consider what this means in the experience of architecture. If you will take an imaginary journey through the buildings, you will realize that the particular nature of the organization strongly affects our experience as we wander around and through the actual structure. In the Palladio, for example, after the formal aspect of the façade impresses itself on our vision, we pass up the great rectangular block of steps and under the high spacious portico; then we enter a restricted space of related proportions but given new character by the arch overhead and the opening at the end of the passageway, the curve of which is to be suddenly expanded into the great space of the central hall. This is an orderly progression of parts, and looking around the central hall we see this progression as the plan indicates, extending similarly on all four sides.

This imaginary journey illustrates a quality that distinguishes our experience of architecture from the experience of the other visual arts. Because of its size, because we pass through it, allowing its forms, as they evolve one after the other, to mold and shape our actual environment, a work of architecture wields a peculiar power over our sensibilities. We could describe the effect simply as an experience of space acted on by time.

It is often assumed that space simply exists, but in art space is created. We do not calculate dimensions; we experience them, and our experience is affected by factors other than size. Two simple examples might serve to illustrate this point. Suppose the walls of two rooms of identical size were to be painted—one a rather

dark value of a warm gray, the other tinted in a light gray-blue. Although the dimensions remained the same, the first room would seem to have become smaller, the walls would seem to move in on us, while the second would seem to expand. Few observers would be convinced that the cubic space of the two rooms was indeed the same. In fact, in terms of our visual experience the spaces are not

the same. Consider another example. Suppose you entered a room in which the objects were arranged as in Figure A. Certainly you would be very conscious of the objects, but the space would seem hardly adequate to contain them; in fact, you probably would not be conscious of the space between the objects at all. The same number of objects is shown within the same space in Figure B, but they are so arranged that we become as conscious of the clearly defined space between as of the objects themselves; and in consequence we sense a total space of wider dimensions. It is not that one of these arrangements is "bad" and the other "good"; they provide two quite different experiences of space.

These two examples would suggest that our reactions to space in architecture are provoked by much the same means as are our reactions in painting, and the range of experience thus made possible is equally great. In speaking of the exterior appearance of the two buildings we have been discussing, we noted the difference in proportion. Consider how this difference in proportion and difference in shape, when translated into three dimensions, might bear on our experience. Imagine yourself within the spaces diagramed. It is not size that counts; it is the way the shape and proportions make us judge the size. Compare the interiors of Alberti's Church of Sant'Andrea at Mantua (Figs. 18 and 19), the Cathedral of Rheims (Figs. 20 and 21), and the Pantheon at Rome (Figs. 22 and 23) from this standpoint. There is an insistent movement in the confined and

directed space of Rheims which is not at all present in the other two. On the contrary, in the Pantheon it seems that no matter where we move we remain the center of the great hemisphere. In Sant'Andrea there is a dominant direction of attention toward the altar, but it is equalized by the lateral emphasis which makes the sense of breadth equal in importance to the sense of height and depth.

There is another difference we noted in the views and plans of our two original buildings which is not unrelated to these experiences of space. We noted that the parts were related in accordance with very different concepts of order. You will recall that the parallel planes of the building by Palladio seem to enclose a regular and defined cubic space. In entering such a space we can be conscious at every moment of our position relative to every plane, to every part; we are the one variable in a fixed order. But supposing these bounding planes were rearranged as in the figure below, on the right. Because of this slight readjustment of parts the space itself seems to move, and we find ourselves part of a far more complex organization. In this instance movement is suggested not through shape or proportion but through a new organization of parts. By extending this principle of "fluid" space to the entire volume, this complexity increases. We should be forced to use here, in describing the order which we sense, the statement employed earlier in describing the effect of the exterior of the Wright house: that it is an order sensed within constant change that we seek out in a continuing experience in time.

In examining these few buildings we have discussed a number of points seemingly basic to the experience of a work of architecture. In general we have seen that the experience is determined by forms seen successively in space, relying, therefore, on both space and time, on our immediate impression and on memory. For purposes of analysis we found it convenient to discuss separately the char-

acter of the forms themselves and the way they were put together. As to the forms, we found such matters as proportion, shape, color, and texture helpful in defining their character; but we also observed that this character means little outside the context of the building. The way the forms were composed was more difficult to analyze but more basic to our understanding of the character of the work; our method, like that in the other arts, was to analyze the experience rather than simply the geometric structure. We had in our two principal buildings two quite opposing compositional ideas: a belief in a measured, controlled space comprehendible in its entirety, and a concept of free-flowing space of undefinable dimension—a ranging of forms one against the other in a fixed and stable harmony, and a mingling and overlapping of forms in such a manner that they seem to grow organically. These are only opposing tendencies, not categories into which all architecture can be divided. Each architect can project his own awareness of space, his own new experience of form.

One hears constantly many catch phrases concerning architecture, most of which deal with materials, structure, and use: "form follows function," "a house is a machine for living," "an honest use of materials." For the most part such phrases are dramatic overstatements that have more historical than artistic justification. It cannot be denied, however, that we expect a building to be structurally sound and the kind of structure to be in some measure evident. A part of our pleasure in architecture comes from a sense of structural achievement. If there is an obvious discrepancy between what a building purports structurally to be and what actually it is, we are dissatisfied, regardless of other attractions. As in the other arts, we like to understand the nature of the material in which the work is conceived. You will find much helpful information on structure and materials in chapter iv. But a knowledge of the mechanics of building must be used with caution because very often what we readily experience as structure has little to do with supporting the building. The pilasters on the façade of Alberti's Church of Sant'Andrea seem to exert an imposing upward effort and, because of their flat surfaces and only slight relief, seem imbedded in the very fabric of the building; yet the building is not dependent on their support. Their effectiveness in the design depends on our sensing them as structure, but they are in actuality only expressing a function that the wall itself supplies. It seems evident that our judgment depends not on structural obviousness but on structural expressiveness. The Parthenon has been revered not because its columns are the perfect

minimum dimension for bearing the required weight but because its proportions seem so just and perfect to the eye; this justness we then attribute to the structure. Materials and techniques are important to the artist because new materials and new methods of use make possible new forms, and new forms are necessary for the expression of new experiences. Look, for example, at the interdependence of expression and new materials in such works as the United Nations Buildings in New York City. To use new materials to reproduce old forms is wrong not because it is "dishonest" but because it is a pointless waste of material and creative energy.

Just as the discrepancy between the purported structure of a building and the all-too-obvious actuality destroys for us the pleasure of architecture, so an obvious maladjustment to use might impair our enjoyment. Again we must use care in determining what, in architecture, use comprehends. Are the requirements of use for a church simply that it hold the required number of people and have a place for an altar or pulpit? It is often forgotten in quoting Louis Sullivan's remark that "form follows function" that to him the function of architecture was more the embodiment of a creative idea than the service of physical utility. Physical use must be served, but it must be so thoroughly linked to our formal experience of the building that we could no more separate that which was created by dictation of utility and that created to serve formal expression than we could separate actual structure from structure expressed.

4. SOME MATERIALS AND TECHNIQUES
OF THE ARTIST

DRAWING

Drawings of many different kinds exist and are made to serve a great variety of purposes. On the basis of purpose they might be grouped generally under three headings: the sketch, the study, and the cartoon.

A *sketch* often presents a complete idea or total effect in abbreviated form. It might be drawn from objects, giving the general impression of the thing seen, or it might be the projection of an idea for a more complicated work of art—a painting, a piece of sculpture, or a building. An artist will make many "idea sketches" while planning the composition of a work. He will also sketch freely from nature, trying to catch the character of the things that impress him.

A *study*, as the name implies, is a drawing made to analyze in some detail, or to try out, an appearance or an effect, often preliminary to the creation of a more complex work. Leonardo da Vinci, for example, made many studies from posed models and carefully arranged drapery before beginning the actual painting of a picture, just as Seurat made many studies of light and shade in developing his compositions.

A *cartoon*, in the original sense of the word, is a full-scale drawing made by the artist for transfer to another surface or for translation into another medium. Such drawings are usually prepared for mural paintings, and there is a very famous series created by Raphael for a set of tapestries.

Quite apart from these, however, are drawings intended as complete works in

themselves, such, for example, as Chinese brush drawings, eighteenth-century pastel portraits, and many modern drawings in all media.

The surface on which a drawing is executed, always much in evidence, is of considerable importance. Whereas in the past drawings have been made on parchment, vellum, wood, stone, etc., most modern drawings are made on paper. But paper varies widely in its characteristics. The qualities that most concern the artist are color, absorbency, and surface texture. A wet medium on an absorbent paper creates an effect much different from that made on a harder paper. For both wet and dry media, surface is a major determinant. Papers range from very smooth to rough, and roughness may vary from a course, irregular, pebbly texture to a regular linen-like surface.

The following common materials and techniques of drawing are described separately for clarity and convenience, but it must be remembered that in practice they are often combined. There are also many commercially produced products which in some degree attempt to combine the characteristics of more than one medium, such as pens that flow like brushes or crayons that smear like paint. One must always be prepared to accept new and unusual materials and methods.

Pen Drawing

Pen drawings vary greatly in character depending on the type of pen and the manner in which it is used. Quill, reed, and steel pens are the basic types, but in each there is possibility of great variation. Quill pens are made from the wing feathers of geese or other large birds, cut to shape and split to form a point similar in form to that of a steel pen. It is a pliant instrument allowing the artist a range from fine delicate lines of uniform width to freely swelling lines with sudden rich contrasts of width. If much pressure is applied, the points will separate, producing two parallel lines. With somewhat less pressure the lines become broad like those made with a brush. A keenly sharpened point used with light pressure produces fine lines of great delicacy.

Reed pens, probably the oldest form, are sharpened in much the same way as quills but are much less pliant. Their lines tend to be somewhat angular with more abrupt changes in width.

The steel pen, as we know it, was developed only in the nineteenth century, taking its form from the quill. It has, however, its own distinctive qualities,

chiefly those of firmness and precision. Moreover, the steel pen made possible the development of a wide range of points, some imitating the older pens but others having a character quite their own. The continuous flow of ink provided by the modern fountain pen also has contributed to a new quality of line.

There is relatively little variation of value in a pen line. Range of value in a purely pen drawing must be created by varying the thickness of the lines and the spaces between the lines. To achieve effects of tone, in pen as in many other forms of drawing, series of parallel lines are often used. For richer darks these may be crossed at right angles by another series of lines, and possibly by another series on the diagonal. This procedure is called crosshatching.

One distinctive form of drawing with pen, which placed particular emphasis on light and shade, reached a state of great perfection in the late fifteenth and sixteenth centuries. On a paper toned to the proper degree of darkness to form the middle value of the drawing, shaded areas were indicated by a series of carefully drawn black lines while the light areas were drawn in white. Because of its concentration on the effects of light and shade, this is called a *chiaroscuro* (light and shade) drawing.

Silverpoint Drawing

A forerunner of the modern pencil was the metal point, sometimes of lead, more often of silver. A fine silver point was used on paper that had been coated with a priming to harden it and make it sufficiently abrasive to cause the silver to mark. The line resulting from such a process is precise and delicate. Light gray when first drawn, it later becomes darker and warmer in tone.

Once drawn, a silverpoint line cannot be effectively erased, nor can an area be worked over too much without damaging the paper. It is not, in consequence, a medium lending itself to broad effects or hasty procedures. Silverpoint drawings are characterized by a degree of reticence and subtlety of line rarely to be found in drawings of other media. These qualities were exploited with particular success by the artists of the fifteenth century.

Pencil Drawing

The modern "lead" pencil is made from graphite, pure amorphous carbon, now generally prepared artificially and obtainable in many grades of hardness. Graphite is known, however, to have been used in natural form for drawing as early as the sixteenth century. In its harder forms it takes and retains a fine point.

The pencil line has a somewhat metallic sheen and is therefore never jet black. But graphite permits a very wide range of closely related values from light gray to very dark, a range that can be extended through the use of several pencils of different degrees of hardness. It adheres well and can be used successfully on a great variety of grounds, responding sympathetically to different textures.

"Colored pencils" are simply varieties of chalk, pastel, or crayon made conveniently in pencil form.

Charcoal Drawing

Charcoal is carbon obtained by roasting wood in a closed vessel. Charcoal for drawing is usually made from thin sticks of close-grained wood or vine. It varies from very soft to very hard, but in all cases the line remains in the form of a pulverous substance that does not adhere strongly to the paper and is easily removed or can be rubbed to form soft tones of gray. Tones achieved by applying charcoal directly, however, have a distinctly different character, more vibrant and less uniform, than those obtained by rubbing or wiping.

In general, charcoal adheres best to a fairly soft paper with a marked grain. To prevent damage by rubbing, the completed drawing is often sprayed with "fixative," a thin solution of a spirit varnish such as shellac. Even when "fixed," however, a charcoal drawing can be easily damaged and should be protected by glass.

Charcoal is one of the most adaptable of all drawing media. Because it can be easily erased for repeated correction and can produce renderings of great precision and detail, it has often been used for sustained studies. On the other hand, it is also useful for the rendering of broad tonal effects where suggestion rather than minute detail is desired.

Chalk, Pastel, and Crayon Drawing

Natural chalk, in one form or another, has been used as a drawing material from earliest times. Found in black, white, and a limited range of reds, these three colors became standard for artists. Red, often in a form called "sanguine," was a particular favorite for figure studies through the sixteenth to eighteenth centuries, but very early red and black chalks were used together on white paper to achieve a variety of luminous and textural effects. Drawings in black and white on a toned paper of medium value are also very frequent. In the eighteenth century a highly systematized procedure using all three colors (called the three-color or *trois crayons* technique) was especially popular.

The desire for a greater range of hue prompted experiments in forming finely ground pigments mixed with weak glue into sticks, creating what today are called pastels. When such a stick is drawn across a soft and moderately rough paper, a deposit of fresh, clear color is left. However, color so applied is quite as transient as charcoal and must be protected by a weak fixative. This tends to dull somewhat the brilliance of the initial effect. Eventually pastels were made in a great number of hues, and it became possible to create complete pastel "paintings." Used in combination with white chalk, pastels were much used for highly finished portrait drawings in the eighteenth century, creating works that were light and delicate in color. From this tradition of combining pastels with white to create light and delicate tints came the popular conception of "pastel colors," although modern pastels are obtainable in a wide range of fully saturated hues and deep values.

Charcoal, chalk, and pastel all have the disadvantage of smudging easily because they do not adhere strongly to the paper. To overcome this problem, artists early tried combining in molded sticks pigment and various binding media, such as oil, grease, wax, etc., which might hold the pigment more permanently to the surface. The various products made in this way are generally called *crayons*. Available today in a great variety of kinds, some crayons are soft, some hard; some, such as wax and paraffin crayons, produce glossy marks, while others are relatively unglossy. Like similar drawing materials, crayons respond with considerable sensitivity to the nature of the ground on which they are used. On a very rough paper, for example, a grease crayon under normal pressure would deposit the pigment in isolated dots; on a smooth paper the same crayon would produce a continuous line. Such marked variation is less prevalent in more pulverous media such as pastels.

Brush Drawing

Although a brush can produce lines as fine as those of a pen, brush drawings usually show to advantage the possibilities afforded by the brush of working in broad areas or free-flowing, broadly varied lines. Doubtless the most highly developed technique of brush drawing has been that of the Chinese, in which the various capacities of the brush for making lines of diverse character and size are exploited to the full. In such drawings, the silk or absorbent paper records every movement of the hand, every hesitation of the brush.

Much of the character of the drawing, of course, depends on the brush used. Most often a fair-sized brush of soft but resilient hair, such as sable, so constructed as to come naturally to a fine point, is employed. By using just the tip of such a brush the artist can draw a very fine and delicate line; yet by bearing down and sometimes using the side of the brush, he can readily create lines or areas of considerable width.

Chinese (India) ink was early imported into Europe and has been widely used for drawing throughout the West. It can be used either as a rich, dense black or, with the addition of water, in transparent lighter values. When it is used as a dense medium, there is little possibility for a wide range of values except when the brush is used fairly dry on a somewhat rough surface. This is called a *dry brush* technique.

Brush drawings made up of transparent washes in one or two colors, a method permitting a full scale of values, are called *wash drawings*. Often such drawings are made from a warm brownish color, bister or bistre, a pigment derived from soot, or in the duller brown color, sepia. Wash drawings in black and gray are usually made from water color or diluted Chinese ink.

For the most part, wash has been used in conjunction with other media, particularly with pen and ink and pencil. In such a way strong linear character can be combined readily with the effect of broad planes. Some drawings are created first with broad washes of the brush, then further defined with the pen; others are first drawn with pen or pencil, then given tone with the brush. The difference in concept between such diverse approaches to drawing is usually quite evident in the completed work.

PAINTING

Most of the various painting media used by artists are made from similar pigments but differ in character by virtue of different binding materials. The pigments themselves are, for the most part, solid substances of a variety of kinds—some organic, some inorganic, some natural, others artificial—ground to a fine powder. Some few colors are made from dyes precipitated on a neutral base. To the many natural and manufactured pigments of the past have been added in modern times the synthetic dyes obtained from coal tar, providing the artist with an almost unlimited range of hue. Continual experiment has also been carried on in an effort to create colors that are both brilliant and permanent.

A basic distinction might be drawn between colors prepared with oil and colors prepared basically with water. Pigments ground in water, such as those used for fresco, tempera, and water color, tend to be lighter and, unless spread very thinly, less transparent in effect than those ground in oil; but, unaffected by the darkening tendency of oils and varnish, they are likely to maintain their initial brilliance longer.

Of importance along with the pigments and binding media is the ground or surface on which the colors are applied. Except in the case of some papers, such as those used chiefly for water color, a special ground is usually prepared with a priming or sizing which provides a surface sufficiently dense and of the desired texture for the painting. Tempera paintings and many early paintings in oil were executed on seasoned wood panels surfaced with a smooth coating of gesso. Since the sixteenth century the predominant ground for easel paintings (a term used to designate paintings of a medium, portable size as distinct from mural paintings or miniatures) has been primed cotton or linen canvas, which varies greatly in texture.

The principal equipment of the painter consists of an easel to hold the painting on which he is working, a palette on which to hold and mix paint, a flexible spatula or palette knife, and an assortment of brushes. The palette may be a panel designed to be held in the hand, a slab of glass or marble, or a prepared table top. The spatula or palette knife is used for mixing colors and, on occasion, for applying colors to and scraping colors from the painting surface. Brushes vary in shape, size, and relative stiffness in accordance with the medium used, the size of the painting, and the personal preference of the artist. Several brushes of different size and shape are normally used in the creation of a single painting. Of course paint can be applied in other ways than with brushes: by sponges, rags, fingers, or a spraying apparatus.

There is another meaning of the word "palette" that might be noted here. Because a painter's palette contains the full selection of colors he uses for a given painting, the word often has been used to refer not to the object itself but to the range of hues the artist employs. A painter working with a very few hues might be said to use a very limited palette. A palette may be described as "warm" (with a predominance of reddish hues); "cold" (with a predominance of bluish hues); "high in key" (with light, bright colors); or "low in key" (with predominantly dark colors). A "set palette" is one in which not only the basic hues are

set out on the palette in advance but also the necessary range of values of each, thus minimizing further mixing during the painting of the picture.

Fresco Painting

Fresco was devised as a means for painting directly on walls, for the creation, that is, of mural paintings. In true fresco (*buon fresco*) the pigment, ground in water, is applied to a surface of wet lime plaster which on drying incorporates it into a waterproof film of crystalline carbonate of lime. Ordinarily the lime serves not only as a binder but also as the white pigment. Only a limited number of pigments are lime-proof and suitable for use in fresco, but these are exceptionally permanent. Indoor frescoes are among the best preserved of all mural paintings, and outdoor frescoes have been known to withstand exposure remarkably well.

Preliminary to painting a fresco, the wall, which must be sound and free from dampness, is given one or more coats of plaster made from lime and sand. Often the artist then transfers his cartoon to the wall to judge the effect of his design before proceeding. When the artist is ready to paint, a very fine layer of smooth plaster is applied over that portion of the surface that the artist intends to finish in one working period. This smooth coating, called the *intonaco*, is made from very fine sand, lime, and sometimes marble dust. Onto this surface the artist transfers his final design and proceeds to paint with his water-ground pigments while the plaster is still damp. If a portion of the final *intonaco* coat remains unpainted at the end of the working period, it is scraped away before it dries since true fresco must be painted on fresh plaster. A large fresco is completed, then, in small sections at a time, often carefully predetermined so that their joinings correspond with contours in the painting and are thus less conspicuous.

The transfer of the cartoon to the wall may be accomplished by perforating the lines of the drawing with tiny holes through which charcoal dust can be pounced onto the wall. Or the design may be incised into the soft plaster by tracing a point over the lines of the cartoon as it is held against the wall. The slight incisions made by this latter method may remain visible and at times accent the painted contours.

Water Color

Transparent water color is made from very finely ground pigment with a binder usually of gum arabic or glue. It gains its particular brilliance from the application of transparent washes over a white ground. To retain this transparence no

white pigment is used, but the white of the painting surface is utilized to produce all whites and high values. The painting surface is, in consequence, of prime importance. While water colors have been painted on gesso, ivory, and many other grounds, the modern water colorist usually prefers paper. The best paper for painting is pure white and made from linen rags. It is obtainable in many different surfaces from smooth to very rough and pebbly. Wood-pulp papers tend usually to absorb water too readily and turn yellow with age.

The lighter values of transparent water color can be brilliant and subtly modulated. Very low values, however, tend to become dull and flat, making it difficult to maintain fine color distinctions. English water colorists of the early nineteenth century discovered that their richest color was to be had in the middle values.

Water-color painting may be broadly and boldly brushed, or it may be built up with careful layers of color and precise contours. In either case, careful planning is necessary since alteration is difficult—once the white of the paper is obscured, it cannot be recovered—and overworking saps the colors of their vitality.

Opaque water colors are much the same as transparent water colors in structure but depend on white pigment rather than on the reflection of the white ground through transparent washes for high values. This permits much freer handling than with transparent colors since light areas can be added and need not be calculated from the start. However, opaque colors have less brilliance than transparent colors, tending to be rather chalky in appearance. The most commonly used opaque water color is *gouache*, which is manufactured with various binding media, chiefly gum, and is sufficiently fine to be used in semitransparent washes as well as in thoroughly opaque strokes. Casein paint also might be mentioned here, although it is discussed under the heading of tempera.

Many commercial colors called "poster colors," "tempera colors," etc., are basically opaque water colors, often coarsely ground, with various gum or glue binders and preservatives.

Tempera

True tempera as used for the luminous paintings of the fourteenth and fifteenth centuries was made from pigment ground in water and mixed with egg. The word has been used very broadly, however, and refers at times to paints mixed with gum or glue. A "fatter" medium than simply egg or egg yolk and water, giving greater transparency to the color, has often been made by adding oil in accordance with any of a number of special formulas.

Tempera color dries quickly and in time becomes very hard and permanent. Its blending quality and transparency vary somewhat with the formula used, but the surface normally is smooth and unglossy. As in most water-ground paints, brush strokes do not fuse as in oil paint, but tend to remain separate and precise. The subtle blending of hues and values is achieved by weaving together minute strokes of the brush. This meticulous way of working often produces in tempera painting a characteristic clarity and sharpness of form that shows off to advantage subtly designed contours and patterns of shapes.

Although tempera can be painted on paper, cardboard, prepared canvas, and many other grounds, the traditional ground has been the wooden panel with a smoothly polished surface of gesso. The ground is prepared by first sizing the panel with glue, then covering it with several thin layers of gesso—basically a mixture of chalk, whiting, or slaked plaster and glue. Each coat of gesso is carefully sanded before application of the next so that the resultant surface has a polished smoothness. It has been customary to work directly on this brilliant white surface, building up the colors with care, since the hues derive some of their vitality from the reflecting base. When gold leaf was used in early panel painting, however, it was habitually laid over a colored ground, usually red (bole), which is now sometimes visible through the gold.

After the introduction of oil paint for artistic purposes late in the fifteenth century, tempera paint was used often for underpainting for the more transparent oil. The mixed technique produced colors of exceptional brilliance and richness and has been adopted at times by modern painters.

A medium which might be included either under the heading of tempera or of opaque water color is *casein*. Casein is a remarkably strong binder derived from skimmed milk. Most commercial paints employing it can be thinned with water and used in either transparent or opaque form. It can also be used with considerable body, as with oil paint. Once the paint sets it is relatively waterproof and can be worked over indefinitely since added layers of paint do not merge with those beneath. Casein paints are sometimes used as underpainting for work in oil.

Oil

For oil painting the pigment is mixed with a drying oil such as linseed, nut, or poppy-seed oil. The paint is thinned with turpentine or petroleum, which may or

may not be combined with drying oils or resin. First widely adopted as a painting medium in the sixteenth century, oil paint was prized by the artist for its transparency, the richness of its colors even in low values, and the ease with which it could be manipulated. Subtle transitions of value and hue can easily be created in oil paint because it permits one stroke to fuse with another. The range of effect is further enlarged by the possibility of contrasting thinly painted, transparent areas with thickly painted, opaque sections. With more body than most other media, oil paint can be made to stand out from the surface to catch the light (when it is used as a heavy medium in this way the technique is called *impasto*) and can be mixed with sand and other material for surface variety. On the other hand, oil paint can produce a surface of enameled smoothness.

Prepared linen or cotton canvas has been the most used ground for oil painting although a great variety of grounds have been used. The canvas is prepared by sizing with glue and then applying one or more coats of lead white, zinc white, and/or whiting mixed with glue or with a drying oil.

The brushes for oil painting vary according to the effect desired. Bristle brushes, often thin and flat but also round, are most used in the manipulation of heavy paint and tend to leave distinct brush marks. Softer brushes are used where subtle blending is desired and the artist wants all trace of the brush to be lost. Where an exceptionally bold manipulation of paint is wanted, the palette knife is used.

Oil paintings have been regularly protected with a coating of varnish which with age often turns dark and yellow. Many "old master" paintings seem dark and dull in color only because we see them through such an obscure coating of varnish. Once this dark layer is skilfully removed, the colors reappear in almost their original freshness.

Synthetic Painting Media

Introduced for general use in the 1950's, pigments bonded with acrylic polymer emulsion or some other form of synthetic resin quickly were accepted for a wide variety of uses. In popular usage they have been called generally "acrylics." Although some are soluble in water during application, they dry quickly with an insoluble, resistant finish and can be painted over almost immediately since underneath layers will not mix with the newly applied paint. Acrylics can be applied to any non-oily surface and have been used as often on

paper as on both sized and unsized canvas. Depending on the painting medium used (various preparations are available), acrylic polymer emulsion paints can assume many forms. They can be applied in transparent washes (the large "stained" canvases produced in the 1960's were usually painted in acrylics), take on the matte appearance of gouache, or assume the body and translucency of oil paint.

Encaustic

In encaustic painting the pigments are combined in some way with wax. This was a widely used medium in ancient times, but just how it was prepared and used is not clear. In one modern method the colors are melted on a heated metal plate and applied rapidly with a coarse brush or palette knife. Usually the ground is a prepared wooden panel, but other types of ground also are used. Although a difficult medium to handle, encaustic can be very durable; brilliant examples exist which were painted in Egypt in Roman times.

An Extension of Painting

Defining what constitutes a painting, as distinct from sculpture or some other form of art, has not been of concern to twentieth-century artists. Already in the second decade of the century they had departed from tradition by affixing various materials to the surface of their canvases—cloth, wallpaper, newspaper—often combining the actual fragments with painting and drawing. The result was called a *collage*, which in French refers to something glued or pasted, and the term has persisted. Materials thus incorporated retain their own character, together with their particular associations, while becoming at the same time part of a new structure. Although also pasted assemblages, such works as Henri Matisse's colorful paper cut-outs (découpages) pasted down in colorful compositions (papier collés) are in quite a different category, since the materials bring no associative qualities of their own. As the line between painting, construction, and sculpture became increasingly vague, actual objects or their fragments were brought together to take part in the pictorial presentation, a procedure referred to generally as *assemblage*. Adding quite another procedure, Robert Rauschenberg popularized the combining not only of objects but of silkscreen printing with painting, making possible the incorporation of repeated images, often taken from a commercial publication. Possibly a new word is needed to encompass both traditional painting and such combinations.

Related Techniques

Closely associated with painting both in concept and design are three media, each with a long tradition. *Mosaic,* which has served for murals, floors, and portable pictorial panels, is made by assembling small bits (tesserae) of stone, colored glass, ceramic, or other material to form a design or image, and fixing the tesserae in a mortar ground. *Stained glass,* used traditionally for windows, is made by joining shapes of colored and sometimes painted or molded glass with lead strips. *Tapestry,* which has served often in place of mural painting, incorporates the pictorial design into the actual weaving of the fabric, unlike various forms of embroidery in which the image is created by stitches on a finished cloth.

GRAPHIC ARTS

There are four basic types of printing processes—relief, intaglio, planographic, and stencil. In the *relief process,* the print is made from the surface that remains in relief after areas of the block have been cut away. In the *intaglio process,* the print is made from the lines that are cut or etched into the surface of the plate. In the *planographic process,* the print is made from a flat surface on which the printing and non-printing areas are approximately of the same level but are distinguished by differences of substance. In the *stencil process,* the print is made through openings or perforations in a stencil or screen. In the first three types of printing processes the design is reversed when printed. There is no reversal in stencil-printing.

As an artist works on a print, he often makes trial impressions, or proofs. These proofs record the various states through which the work has progressed and are so classified, i.e., first state, second state, third state, etc. Since relatively few impressions are made of these intermediate states, such impressions are much in demand among collectors. But they have value, too, as records of the development of the artist's ideas, of his method of working, and as evidence of what satisfied him and what failed to satisfy him.

When the final state is reached and the artist is satisfied with the print, a number of roughly identical prints are made, their number depending on the process used and the desires of the artist. This is called an *edition,* and often the print-maker records in the margin of the print the number of the impression and the size of the edition. Thus, 3/25 would indicate the third print made, after the

artist's own proofs, in an edition of twenty-five. Often the printing surface is destroyed after an edition is printed.

Although the following techniques are treated separately, more often than not they are combined in practice. Aquatint is usually combined with etching or engraving, drypoint often is used to accent etching, etc. It is wise to think of a print first as being relief or intaglio, for example, rather than trying to define it as an "etching" or a "drypoint."

Relief Processes

The material required for a *woodcut* is a block of close-grained wood, cut with the grain running parallel to its surface (plankwise), and of even thickness or height (usually as high as the metal type used in printing—0.9186 inch). The woods commonly used are pear, apple, cherry, sycamore, and beech. Although not as suitable to fine work as wood, heavy linoleum or rubber glued to a wood backing is sometimes cut and printed much as a woodcut.

The tools for cutting the wood block range from a simple knife blade, used for all cutting, to elaborate sets of specially shaped veiners and gouges. The artist ordinarily begins by making a drawing in reverse directly on the surface of the block, on paper to be pasted to the block, or on paper from which it may be traced on the block. Next, the parts of the design that are not to print are cut away, leaving the printing surface of the block standing in relief—hence the name for this process.

To print the block, printing ink, composed of pigment (often carbon black) ground in heavy, quick drying linseed oil, is first spread evenly on a non-absorbent inkslab. Then it is taken up from the inkslab with a cloth dabber or with a rubber or composition roller and is applied evenly and thinly to the raised surface of the wood block. When the block has been inked, a sheet of paper (often dampened) is placed on the inked surface, and the impression is made by applying pressure with a press or by rubbing the back of the paper with burnisher or baren. The block must be re-inked for each impression.

ELEMENTS OF PRESS FOR RELIEF PRINTING PROCESS

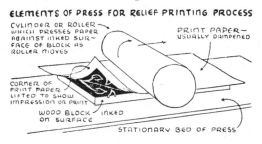

CYLINDER OR ROLLER—
WHICH PRESSES PAPER
AGAINST INKED SUR-
FACE OF BLOCK AS
ROLLER MOVES

PRINT PAPER—
USUALLY DAMPENED

CORNER OF
PRINT PAPER
LIFTED TO SHOW
IMPRESSION OR PRINT

WOOD BLOCK INKED
ON SURFACE

STATIONARY BED OF PRESS

Color prints from wood blocks usually require a separate block for every color to be printed. The blocks are cut to print in accurate "register"—in correct alignment on the paper. Although the color areas are sometimes kept separate, they are often superimposed to secure additional color effects.

The *wood engraving* is similar to the woodcut in that the non-printing areas are cut away, leaving the printing areas standing in relief. It is inked and printed in the same fashion. In fact, in casual usage, the term "woodcut" sometimes refers to both wood engraving and woodcut. The wood engraving differs, however, from the woodcut in that the block (of hardwood, usually boxwood or maple) is cut so that the grain of the wood runs at right angles to the surface of the block. This "endgrain block," as it is sometimes called, is polished to a glass-like surface from which very fine lines can be cut, permitting delicate tones and greater detail than is usual with the woodcut.

Another difference is in the tools ordinarily used to make the wood engraving. Although woodcut knives, veiners, and gouges may be used, the wood engraver customarily uses tools similar to those of the metal-plate engraver—gravers or burins. The principal gravers are the lozenge, anglet, and spitzsticker (pointed tools making fine lines of varying widths); various scorpers (tools with a square or rounded cutting edge for broad lines and for clearing out non-printing areas); and the tint tool (with multiple points for cutting several parallel lines at once) used in shading.

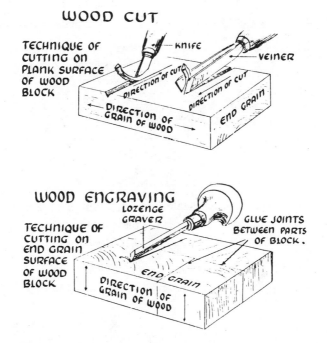

Intaglio Processes

The printing of an intaglio plate differs radically from printing from a wood block or other surface cut in relief. Instead of depositing ink on the raised surfaces, the printer must fill the lines with ink and wipe the surface more or less clean. Then it is necessary to force the paper against the plate with great pressure in order to transfer ink from the lines to the paper, and for this a special press is required. The following description applies to all intaglio processes, with minor variations noted in the discussion of each process.

The plate is warmed until about as hot as can be handled, to soften the stiff printing ink, which is then rolled or dabbed onto the plate, and to make it easier to work the ink into the lines. When the lines have been filled with ink, the ink on the surface of the plate is wiped off, usually with tarlatan—a stiff, sized netting. A "fat rag" that has been used before and is full of ink may be used first to drag the heavy ink about. Such a rag can be used also to restore ink to the plate as well as to wipe it off. Some print-makers, especially etchers, take advantage of the effects to be secured by leaving ink in heavy tones on the surface as well as in the lines of the plate. A clean wad of tarlatan may be used to complete the wiping. Printers who wipe the surface of the plate as clean as possible usually resort to "retroussage" to soften the effect of the lines, i.e., the ink is drawn slightly out of the lines onto the surface, with a soft, clean rag, gently touching the plate.

The paper used for printing is always dampened, since it must be forced into the lines of the plate to draw out the ink. The warm plate is put face up on the

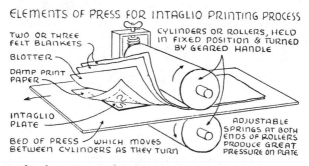

ELEMENTS OF PRESS FOR INTAGLIO PRINTING PROCESS

TWO OR THREE FELT BLANKETS

BLOTTER

DAMP PRINT PAPER

INTAGLIO PLATE

BED OF PRESS WHICH MOVES BETWEEN CYLINDERS AS THEY TURN

CYLINDERS OR ROLLERS, HELD IN FIXED POSITION & TURNED BY GEARED HANDLE

ADJUSTABLE SPRINGS AT BOTH ENDS OF ROLLERS PRODUCE GREAT PRESSURE ON PLATE

bed of the press, the damp paper is laid upon it, a blotter covers the paper, and, as additional cushioning both to protect the plate and to force the paper into the lines, two or three felt blankets are placed over the blotter.

The plate press is a special apparatus, designed to exert very great pressure on the plate and used for printing metal-plate engravings, etchings, dry points, aquatints, mezzotints, and other intaglio plates. Ordinarily it consists of two steel rollers, in a heavy frame, between which the bed of the press (a strong sheet of steel) moves horizontally as the rollers turn. The upper roller is provided with powerful springs and screws at both ends, with which to adjust the pressure of the press. After the bed, together with plate, proof paper, and blankets, has passed slowly between the rollers, the blankets are lifted and the proof is "drawn" or "pulled," i.e., the paper on which the print has been made is peeled from the plate.

The plate must be inked again and printed in the same fashion for each impression that is made. The printer, who is not always the artist, has a very important role in making the intaglio print, for skill and judgment are required in wiping the plate. Many artists insist on doing their own printing.

The number of impressions that can be drawn from a plate is definitely limited, since the plate "wears out" from the repeated wipings and the pressure of the press. The finest lines and most delicate effects disappear first, and thus the early impressions present the intentions of the artist more completely than do later impressions. While it is possible to rework a plate in some instances to extend the number of clear impressions, it is usual for the edition of intaglio prints to be limited.

The plates commonly used for *engraving* are copper—desirable because it is soft metal and more easily cut—and steel—desirable for its hardness which permits a greater number of prints from the plate. Iron, zinc, and brass have also been used. The plates are perfectly flat, highly polished, and range from one-thirty-second of an inch to one-sixteenth of an inch in thickness. Their edges are beveled more or less, as may be seen by examining the "plate mark" on a print, to prevent cutting of the paper and blankets under the heavy pressure of the press.

Several types of gravers or burins are used to engrave the plate, the principal ones being the lozenge and anglet. These are hard steel tools with very sharp points, set in graver handles that permit them to be held nearly parallel to the surface of the plate.

The plate ordinarily rests on an engraver's pad (leather, filled with sand) while the engraver works, to permit easy turning of the plate, especially in making

curved lines. The graver or burin cuts lines of varying depth and width into the surface of the plate, removing a threadlike curl of metal in so doing. The engraved line grows wider as the engraver cuts deeper into the plate and thinner as he releases pressure and changes the angle of the tool to produce a shallower line. It is characteristic of the engraved line to swell and shrink in width, according to the engraver's need for a heavy or light line in the print. Also characteristic of the engraved line are clear, sharp edges in the print, secured by scraping and burnishing away the slight burr or roughness that is left by the graver on both edges of the lines, and which would blur the line if allowed to print.

Although the faintest lines require only slight pressure on the graver, heavy (deep) lines call for considerable force, which must be controlled carefully to avoid slips and overcuts. The easiest line to engrave is perfectly straight; curved lines call for greater skill; and an active, curling line requires technical virtuosity. The wiry, wriggling line and the line ending in a hook, appearing often in etching and easily produced in that medium, are unnatural to engraving and can be produced only with difficulty. Such characteristic differences, arising out of the manner in which the lines of the print are produced, are important means of distinguishing between the various types of print techniques.

The printing of an engraved plate is similar to printing in other intaglio processes. When the plate is copper, the impressions taken from it may be numbered in hundreds; if the plate is steel, many more impressions may be made, numbering in thousands.

Etching—an Intaglio Process

Although other metals have been used, *etchings* generally are made on copper plates. The lines of an etching are "bitten" or "eaten" (i.e., etched) into the plate by the action of acid on the metal, which is exposed where lines are wanted and protected with an acid-resisting coating, the "ground," where the acid is not intended to bite.

The clean, polished plate is "grounded" by warming it enough to melt the ground—a composition of wax, rosin, and pitch, usually formed into a ball and therefore named "ball ground" (distinguishing it from the modern, ether-based liquid grounds that are poured on the plate). Only a little of the ball ground is melted onto the plate, and this is spread evenly and very thinly over the surface with a silk dabber or a roller, to form a protective, acid-resisting film.

Since the thin coat of ground is amber and only a little darker than the plate, most etchers smoke the plate by holding it ground-side down over a lighted candle or taper, melting the carbon from the flame into the ground until the plate is black. Then a line drawn through the ground can be seen clearly as it exposes the bright surface of the metal.

Drawing on the plate is accomplished with needles, which make lines of slightly different widths; with the echode, an oval-shaped point that varies the width of line as it is rotated from narrow to broad side; and occasionally with devices for special effects such as the roulette, a fine-pointed wheel that produces dots suitable for shading, and sandpaper, also used to produce shading or tone by making numerous fine pinholes in the ground. The width of line and consequent blackness of line in the print are determined far more by the length of time the acid eats into the line than by the width of the line drawn through the ground.

The point of the etching needle is blunted and smoothed enough to permit it to glide freely over the surface of the plate in any direction, removing the ground to expose the metal, but not catching or cutting into the plate. The resulting freedom of movement shows in the characteristic etched line: it may be fluent, active, even scrawling, and lines drawn quickly may end in hooks. The stiffness of the engraved line, which comes from forcing the graver through the metal, is missing in the etching, since the point can move through the ground with the freedom of pencil on paper, and a perfectly straight line is hard to produce without a rule.

ETCHING

WOOD HANDLED
ETCHING POINT

WOOD

STEEL NEEDLE
LINE DRAWN
THROUGH WAX

ETCHING
GROUND

DIAGRAM SHOWING
RELATION OF DEPTH OF THE
LINE ETCHED IN PLATE TO
WIDTH OF LINE IN THE PRINT

COPPER PLATES

When the drawing on the plate has been completed, there are several ways in which to etch it with the acid. The ordinary way is to submerge the plate in a tray of acid, after coating its edges and back with some acid-resisting material such as shellac or asphaltum. Another method makes a tray out of the plate by forming a wall of wax around its edges to retain the acid. In still another method, the acid

is puddled on the plate in small quantities and is renewed as it weakens through action on the metal; this last method permits subtle variations in depth of line, since the concentration of acid can be varied and moved about the plate at will, instead of acting equally over the entire surface as in the other two methods.

The acids commonly used are dilute nitric, which tends to widen as well as to deepen the lines, and iron chloride (the commercial engraver's etch, probably similar to Rembrandt's "Dutch mordant"), which deepens the lines with a minimum of widening of the lines. Both acids must be agitated during etching with the traditional feather or with a brush to remove the bubbles formed by nitric or the sediment produced by iron chloride, either of which would interfere with the action of the acid and cause irregular lines. The depth of the lines can be estimated, while the plate remains in the "bath," by knowledge of time, temperature, and strength of acid or by feeling the lines with the point of a needle. As the lines deepen, they become wider.

When the lines that are intended to be faintest in the print have been etched deep enough, the plate is removed from the acid, washed, and dried. Then the lines judged to be sufficiently deep are "stopped-out" by painting them with shellac, quick-drying varnish, or other acid-resisting material. The plate is returned to the acid "bath" for another period of etching, until the next depth of line has been achieved—a depth of line that will hold more ink, to produce a heavier line in the print than produced by the shallower lines first stopped-out. The stopping-out is repeated (sometimes alternated with periods of etching) until the lines to be heaviest in the print are judged to be deep enough.

Sometimes three depths of line are used: first stopping-out the distant, lightest lines, then stopping-out lines in the middle distance, and etching the heavy foreground lines longest. When more subtle distinctions between lines are required in the print, a greater number of different depths of line must be produced in the plate by shorter intervals of etching and stopping-out more frequently.

When the etching is finished, in so far as the etcher can determine without making a trial proof, the ground and stopping-out varnish are removed with a solvent, the plate is inked, and a proof is made of the first "state." If some lines are not deep enough or if additional lines must be etched, the artist may reground the plate, using a roller to deposit the ground only on the surface of the plate without filling the lines; then he may draw more lines and continue the etching. Or he may elect to add lines or strengthen parts that were not etched deeply enough. If he decides that some lines or sections of the design must be removed or redrawn, he may scrape away the metal in such areas of the plate until the lines

disappear, using the "scraper"—a short, curved knife blade—or a three-edged tool (with a triangular cross-section) designed especially for this operation. Scraping produces a slight hollow in the plate that may be leveled by placing the plate face down on a flat, polished steel surface and "knocking up" the cavity by careful hammering on the back of the plate. Sometimes large areas of a plate are scraped out, knocked up, polished, grounded, redrawn, and etched again. These processes continue until the final state is decided upon and an edition is "pulled."

Soft-ground etching is closely related to the regular hard-ground etching. The same ground is used with the addition of some tallow melted together with it. When the soft ground has been laid on the plate it does not adhere as does hard ground and from this fact the soft-ground print derives its special qualities. In the usual soft-ground method, a sheet of drawing paper with more or less grain or texture is placed over the grounded plate. The drawing is made on the paper, usually with a pencil. Wherever the pencil touches the paper and presses it against the plate, the ground adheres to the back of the paper and comes off the plate to expose the metal. The plate is then etched and printed in the usual way.

Since the grain or texture of the paper on which the drawing is made affects the way in which the ground is removed from the plate, the print has some of the qualities of the drawing—i.e., the lines are not hard and sharp but "grainy" as pencil on textured paper. Other textures may be secured, as, for example, cloth, screen, lace, or other such material might be pressed into the ground, creating delicate networks of lines. Of course the etching needle may also be used as in hard-ground etching.

A print may be made without the aid of acid by drawing directly into a copper or zinc plate with a very sharp, strong steel point, i.e., the *"dry" point* from which the process takes its name. The lines of dry point vary from the faintest scratches, drawn lightly and with considerable freedom, to heavy lines drawn with great strength. Since it is difficult to draw the point through the metal to make a heavy line, the print often reveals this effort in stiff, rather straight, and fairly short lines, unlike the freely moving lines of the etching, which must be drawn through the ground alone.

DRYPOINT STEEL POINTS POINTS ARE NEEDLE-SHARP, STRONG ENOUGH TO WITHSTAND PRESSURE IN DRAWING ON THE PLATE

DOUBLE BURR SINGLE BURR

CROSS SECTION OF COPPER PLATE, 1/16 INCH THICK

Even the heaviest drypoint lines are not cut deeply into the plate as compared to heavily etched lines. The drypoint needle turns up a ridge of metal, the "burr," and when the plate is inked and wiped, the burr holds most of the ink. Since the burr is rather fragile, the drypoint plate must be wiped carefully; usually it is finished with the palm of the hand. It is not possible to wipe the drypoint lines entirely clean. The ink left in and around the burr produces a characteristic, slightly blurred line in the print. The blurring of lines in drypoint produces the "soft" quality in the print that is typical of the process.

When lines with heavy burrs are close together, the ink between them cannot be wiped from the plate, and such portions of the plate print heavy, nearly solid tones. Sometimes the burr is scraped off, leaving only the scratch made by the point, and then the line that prints is relatively light. When drypoint lines are added to an etched plate, they are readily identified in the print by the effect of the ink held by the burr, unless the burr has been scraped away.

Except for the difference in wiping, drypoint is printed in the same way that etchings and engravings are printed. Fewer prints can be made, however, because the burr is gradually broken down by repeated wiping and the pressure of the press; from thirty to forty good impressions may be expected from the average plate.

As its name suggests, the *mezzotint* process is suited to the production of middle tones or "tints." Although prints are made by the mezzotint process alone, it has often been used to add tones and shading to line etchings. The surface of the plate is prepared or "grounded" by use of the "rocker"—a blade with a curved edge composed of many fine, sharp points. As the blade is rocked back and forth across the plate in several directions, the sharp teeth dig into the plate and turn up little points of metal to produce an even roughness of surface. If inked and printed, the plate in this condition would produce a solid black.

The tones of the mezzotint are produced by scraping off the burr, more or less, as required for the design. Areas to print white must be scraped entirely clear of the marks made by the rocker and then polished, unless it has been possible to leave them untouched by the rocker in the first place. Since the small points of burr left by the rocker are fine and very close together, they can be scraped to make subtle gradations and transitions of tone and shading. On close inspection, the mezzotint print can be identified by the rows of fine dots that make up its tones.

The *aquatint* process provides another means of producing tones in a print, sometimes in combination with line etching, and sometimes as an independent process. The plate is generally grounded by dusting its surface evenly with powdered rosin; when heated the rosin particles melt and adhere to the plate. Then, when the aquatint plate is etched in the usual way, the rosin particles on its surface protect the plate while the acid eats the exposed metal around and between them. Parts which are not to be etched are stopped-out with an acid-resisting material. Another way of grounding the plate is to dissolve rosin in spirits of wine and coat the plate with the solution; the spirits evaporate and leave the rosin in a crackled surface on the plate. After etching, the rosin particles are dissolved from the plate, and it is inked, wiped, and printed as are other intaglio plates. The tones of the aquatint print are produced by the ink in the irregular pattern etched around the rosin particles; close inspection of these tones will reveal small islands of white of varying size and shape.

The areas of the plate which are to produce light tones in the print are etched a short time and then are stopped-out. Intermediate tones are secured by etching and stopping-out at suitable intervals, while the parts to print the darkest tone are etched longest. Since the stopping-out varnish is applied with a brush, the effects of brush strokes frequently appear in the tones of the print. Definite but slightly irregular lines can be achieved by leaving narrow strips exposed between stopped-out areas.

Color aquatints are made with two or more plates, each of which prints a color, in register, on the paper, producing additional colors, if desired, by superimposition.

Planographic Processes

As the name implies, a *lithograph* is drawn on and printed from a stone, although metal plates with grained surfaces are commonly used in commercial "lithography." The process was invented by Aloys Senefelder about 1796, and the fine-grained limestone found in Bavaria near Solnhofen is considered the best material for making lithographs. The process is based on the principle that oil and water do not mix and upon the affinity of certain stones and grained metal surfaces for both oil and water.

The block of stone, which may be from two to four inches in thickness, is given a smooth, level surface by grinding with coarse, medium, and fine grades of abra-

sive, such as sand or carborundum. The "grain" of the surface can be coarse or fine, depending on the abrasive used last in surfacing the stone.

The drawing is made in reverse, directly on the stone, using a lithographic pencil, crayon, or ink that contains "soap" or "grease" (i.e., fatty acids present in soap, tallow, resin, and wax, such as stearic or oleic) plus the carbon that makes the drawing visible. The fatty acid interacts with the lime of the stone to form an insoluble "lime soap" on the surface of the stone, which will receive printing ink and refuse water. Accordingly, wherever the stone has been drawn upon, it has an affinity for ink.

Instead of drawing directly on the stone, the artist may make his drawing on paper in the medium containing the fatty acid, special kinds of paper being available for the process. The drawing is then placed face down on a heated lithograph stone and run through the lithograph press, transferring the drawing to the stone. This type of lithograph is referred to as a transfer lithograph. Transfer lithographs are sometimes grayer, less brilliant in tone than others, and show

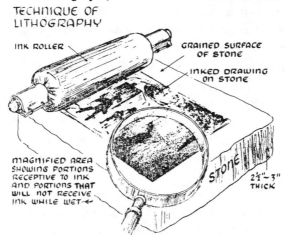

TECHNIQUE OF LITHOGRAPHY

INK ROLLER

GRAINED SURFACE OF STONE

INKED DRAWING ON STONE

MAGNIFIED AREA SHOWING PORTIONS RECEPTIVE TO INK AND PORTIONS THAT WILL NOT RECEIVE INK WHILE WET

STONE

2½"–3" THICK

the grain of the original paper, but the process enables the artist to do his drawing anywhere without carrying around the heavy stones, and he does not have to reverse his design.

Next, the surface of the stone untouched by the crayon is "desensitized" to grease and the grease of the drawn portions is "fixed" against spreading by treatment or "etch" with a gum arabic and dilute nitric acid solution. The crayon of the drawing is now washed from the stone with turpentine and water, since the

grease has penetrated the stone and the pigment in the crayon is unnecessary any longer. The drawing is then restored in ink by "rolling up" with the ink roller. As long as the surface of the stone is kept moist with water, the ink roller will deposit ink on the portions originally drawn upon, while the rest of the surface will repel the ink.

A special press is needed to print the lithograph from the stone. It has a traveling bed that passes under a hardwood bar called the "scraper." After the stone is inked, the print paper is laid upon it, then backing paper, and finally the "tympan"—a strong, compressed cardboard coated with grease. The force of the press is exerted on the stone by means of the scraper, the edge of which, covered with leather, slides over the greased tympan paper as the traveling bed of the press carries the stone under the scraper blade. The stone is re-inked for every impression and must be kept moist with water while being inked to insure that the ink from the roller is transferred only to the areas that make the print.

Lithographic prints have many qualities usually associated with drawings and might be confused with drawings except for the even color and sharp impression of the ink. It is the most autographic of the print processes, since the artist may

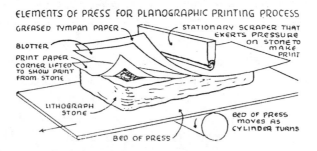

draw with whatever medium he is accustomed to use: crayon, pencil, ink and wash, with great freedom in their handling, unrestricted by the special techniques of using knives, gravers, needles, and acid. The lithograph may have tones ranging from solid black to delicate gray; it may be constructed of lines typical of pencil, bold strokes typical of crayon, or washes typical of ink. An ink-and-wash lithograph is often called a *lithotint*. A peculiar characteristic of the lithographic process is that white lines and areas in the print can be produced by scratching through the drawing on the surface of the stone.

Thousands of impressions of a lithograph can be made from the stone. The ink

may be of any color. In lithographs printed in several colors, a separate drawing usually is made and printed for each color of ink used in the design, and additional colors may be produced in the print by superimposition

Stencil Processes

Prints may be made from *stencils*, i.e., pieces of thin sheet metal, parchment paper, or other material resistant to the ink or pigment used, which are cut and perforated with the desired design. The stencil is laid on the material to be printed and the pigment applied through the cut-out design with a brush, dauber, or roller. Several stencils may be used in succession, in register, to produce a print in color. Stencils are often used to "hand-color" a print made by another process such as metal-plate engraving or lithography. Ordinarily, stencils produce distinct, hard edges between areas of color or light and dark, and do not lend themselves well to detailed, precise work or to freedom in draftsmanship, being more suited to conceptions in large areas rather than in line.

In the *silk-screen* process (*serigraphy*), a water-resistant stencil is created on a fine-meshed screen of silk cloth stretched over a frame. The screen is placed over the surface to be printed, and pigment is pushed through the uncovered parts of the screen by means of a rubber squeegee. By using several screens in succession, one for each color, prints of considerable complexity in color can be created. It is also possible to use a combination of matte and glossy paints and to vary to some degree the textures. Once the edition is completed, the screens can be cleaned for reuse. The screen may be prepared in many ways. One method is to paint directly on the screen with a water-resistant medium, tusche, then coat the screen with glue. The tusche is dissolved with turpentine or benzine, leaving the glue to form the stencil. In printing the paint will penetrate the areas that were painted in tusche. Many photographic methods have been developed for the preparation of the stencil, making it possible for the artist to incorporate images from other sources—newspapers, photographs, book illustrations—in his work. Photographic procedures are also often used in making a silk-screen print from an existing drawing or painting.

Other Print Processes

The *monotype* differs from the other print processes radically in that it produces only one print and is classified as a print process only in that it transfers

the pigment from one surface or plate to a final ground. Generally the design is drawn or painted, in full color if desired, with slow-drying pigments upon a surface that will not absorb the pigment, such as a sheet of glass or metal. While the pigment is still wet the final ground is laid over it and rubbed on the back or put under pressure so as to transfer the pigment to the print.

Photography, which produces images or designs on a chemically sensitized surface by the action of light, might in some ways be considered a print in the sense in which the term is here used. Two less well-known types in particular may be noted. Whereas a photograph commonly utilizes a lens and a camera to record an image on a negative, a *photogram* frequently dispenses with lens and camera to produce designs and images directly on sensitized paper by other means. Often opaque and transparent objects are assembled on the paper which is then exposed to light. *Cliché verre* is the name given to prints made by a method in which a design is scratched into the opaque ink or paint coating of a sheet of glass to form a negative from which prints can be made on sensitized photographic paper.

Printing processes of the plastic arts are, of course, closely related to the printing processes used for the production of books, magazines, newspapers, facsimiles, reproductions, and other printed matter. Some modern artists have made special uses and adaptations of the technical inventions that industry has added to the basic processes. The commoner commercial processes related to the relief print are the photoengraving, halftone, and line cut; to the intaglio print, photogravure, and rotogravure; to the planographic process, photolithography (offset lithography) and the photogelatin process (collotype or gelatone). As can be seen in their names, these processes usually involve photography as the means of producing the design on the plate and controlling its cutting.

SCULPTURE

The materials of sculpture are varied and tend to increase in number, but only the common ones will be discussed in connection with technical procedures. It is convenient to distinguish four principal branches of technique—carving, modeling, casting, and construction.

Carving includes the familiar work in wood and stone and any other materials, such as plaster, metal, ivory, bone, and plastics, that can be shaped by cutting away parts of the original block. Woodcarving and stonecutting are very old

arts that offer a test of skill for any artist, since it is difficult or impossible to replace portions once cut away. Drawings on paper and on the sides of the material to be carved help the sculptor to visualize the work. Small three-dimensional sketches of the projected object, carved or modeled, also have been used to guide the cutting. Whatever his method and however clearly he may imagine his work in advance, the sculptor will take advantage of change that may be forced upon him by accident of material or treatment or that may evolve as new intention while the work is in progress.

Both stone and wood have grain that must be respected, varying with the kind and even with the individual piece. In the first stage it is usual to rough out the main form of the work, using hatchet, saw, drill, rasp, as well as chisels and gouges in woodcarving and sledge, pick, point, and various chisels in stonecutting. In large work there is much heavy labor at this stage, simply knocking off the unwanted portions of the block, with no more than approximation of the final shape in mind. It is possible, however, as some of Michelangelo's works indicate, for the artist who sees his intention clearly to cut very close to the final surface from the beginning. At all events he must avoid splitting or fracture that would endanger the material he intends to remain as part of the completed work.

Following the hewing out of the rough form, there comes a stage in which the planes and contours of the object are made more complex by addition of detail

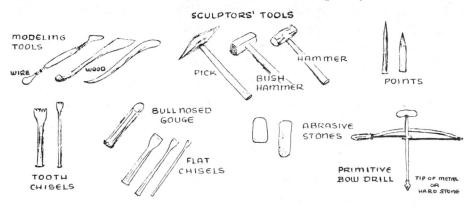

or simplified by smoothing away irregularities, as the sculptor may purpose. The tools used for rough work usually are no longer suitable. The woodcarver turns to chisel, gouge, knife, and file, placing his work in a vise or otherwise securing it, and refines the form of the wooden object by cutting, sometimes with pressure

of hand alone and sometimes driving the cutting tools with mallet blows. Some of the woodcarving chisels and gouges resemble carpenters' tools (which may be used), while others, especially the small ones, have handles to fit the palm similar to those used on engraving tools.

The sculptor working in stone uses a variety of special tools in the corresponding stage of his labor. His points of hard steel, like spikes, are held against the work and driven with a steel hammer, to chip away the stone. They are capable of producing rough textures that may appear in the finished work. The steel bush hammers have from six to several hundred points or teeth on their faces, which wear away the stone. The hammer with few teeth makes a coarser surface than one with many; the latter can be used for very fine textures, and both are more commonly used on hard stones such as granite than on soft stones such as limestone. With marble, limestone, and other soft stones, the tooth chisels are used. These are flat chisels with serrated cutting edges that permit deeper and more rapid cutting than is possible with the simple flat chisels used for finishing work. Drills, saws, gouges, and bull-nosed chisels were used by Greek sculptors and may be used by modern workers when their effects are suitable.

The final surface is achieved with the same tools used for the preceding work when their characteristic textures are desired. For smoother surfaces additional equipment and processes are necessary. Wood may be smoothed with files and sandpaper and finished with wax, oil, shellac, French polish (shellac and oil), varnish, and paint, including colored pigment. The finer finishes on stone begin with rasps and files, proceed through rubbing with finer and finer abrasive stones, depending on the material and effect desired. Soft stones such as marble may be rubbed down with sandstone and pumice stone, using crystallized oxalic acid and putty powder for the final polish. Hard stones are smoothed with varying grades of carborundum or emery powder, and completed with the extremely fine putty powder. Sometimes the color and richness of the stone are modified by a final application of oil, and sometimes color is applied.

When sculpture in stone is produced by the professional stonecarver instead of the sculptor, the steps are similar except that the artist provides the stonecutter with a finished model, usually of plaster and often smaller than the work desired in stone. Since the stonecarver is not free to change the work during carving and must produce a faithful replica, a mechanical device called the pointing machine is used. There are several versions of this machine, suited to small

and large work, based on the same principles of three-dimensional enlarging or copying. A great many points are marked on the surface of the model, the machine is adjusted to the degree of enlargement called for, and similar points are located in the stone by drilling into the rough-shaped form to the depth indicated by the pointing machine. After a sufficient number of points have been drilled to locate and define the surface of the statue that is to be carved, the remaining stone is cut away to bring the work to the finishing stages.

Modeling is a process of adding to rather than taking away. Plastic materials such as clay, wax, and plasticine (clay mixed with wax and mineral oil) allow the artist great freedom in building up and modifying a form. Although it is possible to approach the work by carving into a pre-formed block, as with harder materials, modeled sculpture is usually built up either by the adding of part to part or the filling out of a preconstructed framework. The hands themselves are primary tools, but various wood and wire-modeling tools are used, often produced by the sculptor in shapes and sizes to suit his purposes.

For large works or works with projecting forms and light supports whether clay, wax, or plaster is used, the modeling is accomplished over an *armature*. The armature for a portrait bust may be no more than a wooden upright with one or more crossbars; that for a full figure may be of wire, lead pipe, or an extensive construction of wood, depending on the size. For a figure of half life-

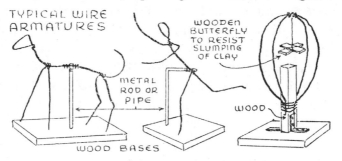

size or less, usually wire and lead pipe are formed into the required shape; for larger works a rough wooden armature may be constructed so as to reduce the coating of clay or plaster required to a minimum.

Clay, wax, plasticine, and plaster are none of them permanent materials; they mark intermediate rather than final stages in the production of sculpture. For materials other than clay, casting is the only way to render the work in perma-

nent form. Clay, however (clay mixed with water, not plasticine), can be fired. Sculpture in clay designed for firing will have no armature and must usually be hollowed out to allow more equal expansion and contraction of all parts, large and small, during firing. When such a piece is thoroughly dry, it is fired in a kiln at temperatures ranging from 1,500 to 2,000 or more degrees Fahrenheit, sufficient to fuse some elements of the clay. Very small sculpture with fine detail is usually executed in fine pottery and porcelain clays; other pieces are generally executed in somewhat coarser clay which, when fired, is called *terra-cotta*.

Casting in plaster is the first step toward rendering more permanent in stone and metal a work which has been modeled in a soft material. A plaster cast is more durable and easier to handle than the fragile clay or soft plasticine. When the clay, wax, or plasticine model is ready, plaster of paris is used to form a mold. The usual sculptor's mold is made in several parts to permit removal of the model. The parts of the mold may be divided by inserting thin strips of metal in the model where the mold is intended to separate, or by placing strong thread on the surface of the model. Then the plaster can be applied to the whole work in one operation. When the thread is used, it must be drawn out in such fashion as to divide the mold into its parts just before the plaster sets hard. For larger molds and whenever thick clay walls are used to block off the sections, the parts of the mold are made one by one, and the partitions are removed after each section is cast. Large sections or weak parts of a mold, such as legs of an animal, may be strengthened with burlap, excelsior, or pieces of wood and metal set in the plaster. Ordinarily these molds are used only once, being destroyed in removing the cast. Such molds are therefore called waste or chip molds, and are made as thin as may be safe—one-eighth to one-half inch, depending on size.

When the plaster mold has set, it is removed from the model (often the model is destroyed in the process), washed clean, and coated inside with soap, oil, or shellac to keep it from adhering to the plaster of the cast. When the mold is reassembled for casting, thin parts may be strengthened by inserting metal inside the mold. Then a fresh mix of plaster is poured into the mold and washed around to insure an even surface in the cast. Small casts usually are solid, while large ones are made hollow and reinforced inside with cloth, excelsior, wood strips, or metal.

When the plaster of the cast has set, the mold is carefully chipped away. Many sculptors complete the work by carving on the cast. Plaster may be left in its natural whiteness, may be waxed, or may be colored to resemble bronze or stone.

Varieties of cast stone, similar to concrete but composed of special materials selected for color and texture, are used instead of plaster for more durable pieces; but since plaster casting is inexpensive and requires no special equipment, it often is used in the first full realization of the sculptor's intention.

For *bronze casting*, the plaster cast, and more rarely a wooden model, is required. Small works may be cast as a single piece, but large sculpture often is cut apart to be cast in sections, later welded together. The plaster model is first half-imbedded in sand, to the mark at which the mold is intended to divide. Then French sand (clay, silica, and alumina) is pressed against the exposed, upper half of the model and is pounded firm to form the mold sections, large and small, required for the particular piece. In a large mold there will be many small sections held together by a larger incasing mold of French sand, itself within a strong iron frame called the flask. All mold parts are made so that they may be removed without damage to themselves or to the plaster pattern.

When half the mold has been made, mold and model are turned over to make the other half. When the entire mold is done, the plaster model is removed and replaced by a sand core, if the cast is to be hollow, as it usually is. The entire surface of the sand core must be scraped down one-eighth to one-fourth inch— enough to leave space for the metal of the cast between core and mold. The sand core is suspended within the mold by means of iron rods protruding from the mold into the core. In addition, various channels and gates are scraped in the mold to permit the influx of metal and escape of air.

Next the mold and core are oven dried, the mold surfaces are smoked to prevent adhesion of the metal, the mold is reassembled, and molten bronze is poured at about 1,900 degrees Fahrenheit. After brief cooling the mold is broken away and the surface of the piece is chased—worked over with chisels and files to remove mold marks and other imperfections of surface. The final finish, called patina, may be secured with various acids as coloring and texturing agents or may be left to exposure and time. More than one cast may be made from the model by repeating the process, yielding an "edition" of the sculpture.

The method for bronze casting described by Renaissance writers called the *cire perdue*, "lost wax," method was somewhat different. The method is now rarely used except for small figures. A heat-resistant core of brick dust and fireclay was modeled by the sculptor to about one-quarter inch or less of the final surface. Then a layer of wax representing the thickness of the metal to be cast

was laid over the core and in it the artist worked out the details of his piece. Providing gates for the pouring of the metal and escape of air by modeling them in wax also, he then completed the mold by applying a sufficient thickness of the clay mixture over the wax. Appropriately placed iron rods connected model and mold to keep them properly apart after a fire built under the statue melted out the wax, leaving space between core and mold into which to pour the metal. Since the wax model was melted, the core inside the cast removed in small pieces, and the mold generally destroyed in removal, only one cast could be made without repeating the entire casting process.

Construction as a significant method of sculpture and not simply as an expedient for achieving variation of color or extending insufficient materials, is principally of modern origin. As with the *collage* in painting, identifiable objects or parts of objects are sometimes assembled in such a way that they take on new form and meaning. More often, however, the sculptor builds his work directly from welded metal, wire, plastic, wood, etc., so that the structure and the character of the materials remain always evident, contributing to the effect of the whole. It is a very direct method of sculpture bringing the observer, as with drawing, into close contact with the creative process of the artist. Unlike other methods of sculpture, it is usually concerned more with the definition of space than with mass, affording experiences quite new in the field. Sometimes actual movement plays a part, as in the *mobile* where loosely linked shapes are arranged in such a way that they will move in patterns of constantly changing rhythmic relationship.

ARCHITECTURE

Materials

The numerous materials of architecture, selected for strength, durability, and appearance, include some, such as wood, clay, and stone, that have been used for centuries and others, such as steel and plastic, that are comparatively recent innovations. Familiar materials continue to be used in familiar ways, as in brick masonry and wood-frame construction, while old and new materials are given new forms and new properties—e.g., plywood and pressed wood, precast and prestressed concrete, plasterboard, and glass brick. Furthermore, new principles and methods of construction transform the uses of familiar materials—e.g., materials under tension, such as steel cables in the geodesic dome construction and

the inflated plastic segments of a similar dome, combine great strength with lightness and economy of the material.

Structurally considered, the materials of architecture are used under compression (a strain tending to crush the material) as when stone is laid upon stone to form a wall, under tension (a strain tending to pull the material apart) as in the cables of a suspension bridge, or in a combination of tension and compression as in a roof timber that spans a space between walls and is compressed in its upper portion while under tension in its lower portion (see "Principles of Reinforced Concrete" diagram, p. 129).

Techniques

The physical requirements of building which the architect has always had to consider might be grouped under three headings: the effective spanning of a space, the efficient supporting of the spanning members, and the inclosing of an area in a way suitable to the use of the building. Notable architecture has always provided solutions to these requirements in a way inseparable from fine expressive design.

The wall has been the primary element in much architecture because it can serve both to inclose a space and support a roof span. A wall can be pierced by windows and interrupted by columns yet still retain its character and function as inclosure and support. But the higher a wall of heavy material such as stone is built, the thicker it must be at its base to withstand the increased pressure, and the more attention must be paid to its stability. This at once suggests a limit to the serviceable height of a brick or masonry wall: when a disproportionate amount of floor space must be sacrificed to the wall, the structure ceases to be practical. If such height is desired, new methods of construction must be found. Similar problems exist with regard to the column and other architectural forms, and in this way considerations of structure and material enter as very real factors in the history of architecture.

Post and Lintel Construction

The oldest and simplest technique for supporting roofs and spanning openings is the post and lintel method of construction. The requirements are simple in principle: the lintel must be sufficiently strong in both compression and tension to span the space and support the required load without breaking; the supports

must be rigid and sufficiently strong under compression to bear the weight of the lintel and its load without crumbling.

A lintel from a material such as stone, which is strong under compression but weak under tension, must be relatively thick to span a wide opening. It follows that columns supporting such a lintel must be proportionately heavy to sustain the weight, and their heaviness would have to be increased if they were to remain firm at a greater height. The problem thus posed can be seen in the colonnade from the Egyptian temple at Luxor and the floor plan of the Great Hall of the temple at Karnak. At Karnak the tall heavy pillars (those of the center are about seventy feet in height) would seem to pre-empt an inordinate amount of floor

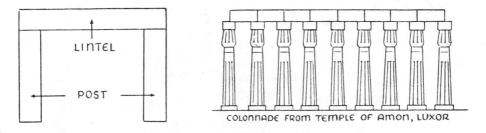

COLONNADE FROM TEMPLE OF AMON, LUXOR

space to uphold the heavy stone lintels required to span spaces of some twenty-four feet. With materials of great weight the limits of post and lintel structure are soon reached. The technique is most flexible for smaller structures and in those using wood, steel, or ferroconcrete with their greater tensile strength.

THE PARTHENON, ATHENS
AN OCTASTYLE PERIPTERAL TEMPLE, COM-
PLETED c 438 B.C. DIM. 228' x 102' x 65'

1. PRONAOS
2. NAOS or CELLA
3. STATUE OF ATHENA PARTHENOS
4. INNER CELLA

GREAT HYPOSTYLE HALL, KARNAK

The plan of the Parthenon shows a different concept of building in the wider and more open interior space, spanned with wooden beams and rafters. The small size of the column bases within the cella suggests that a double colonnade was used—one set of columns supporting another as in the temple of Poseidon at Paestum—to avoid the necessity of heavy columns inconsistent with the other

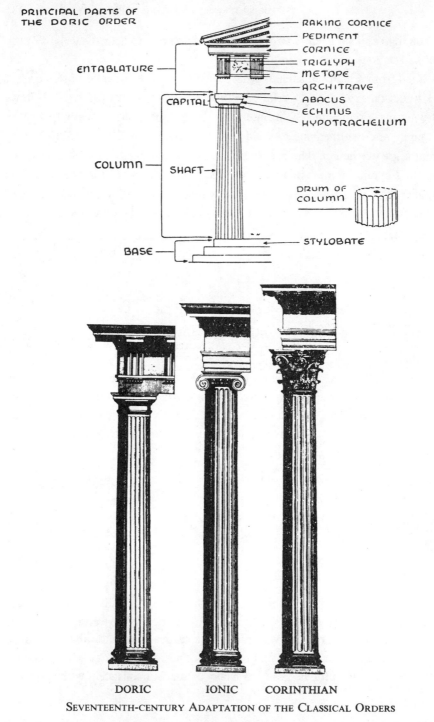

PRINCIPAL PARTS OF
THE DORIC ORDER

RAKING CORNICE
PEDIMENT
CORNICE
TRIGLYPH
METOPE
ARCHITRAVE
ABACUS
ECHINUS
HYPOTRACHELIUM

ENTABLATURE

CAPITAL

COLUMN

SHAFT

DRUM OF
COLUMN

STYLOBATE

BASE

DORIC IONIC CORINTHIAN

SEVENTEENTH-CENTURY ADAPTATION OF THE CLASSICAL ORDERS

Reproduced from Claude Perrault, *A Treatise on the Five Orders of Columns* (London, ca. 1700), courtesy of the Art Institute of Chicago

proportions of the building. The most subtle post and lintel proportional schemes were those developed in Greece beginning about the seventh century before Christ. Through the succeeding centuries three basic systems of varying lightness in proportion came to be codified and eventually subjected to rules. These were the Doric, the Ionic, and the Corinthian orders. The word "order" refers not only to the style of capital but to the entire proportional scheme relating entablature, column, and base. The variations on these three basic orders are numerous.

Arch

The principle of the arch applied to construction in stone permits a greater span between supporting columns than that generally afforded by a lintel. In general, the arch transmits the pressure of weight above the opening downward through the columns to the ground, mainly as compression, with a minimum of tension against which most materials are weaker.

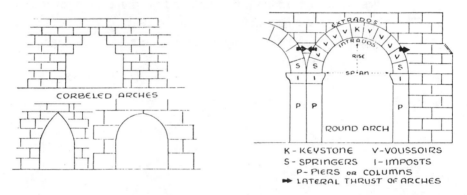

K - KEYSTONE V - VOUSSOIRS
S - SPRINGERS I - IMPOSTS
P - PIERS or COLUMNS
➡ LATERAL THRUST OF ARCHES

The *corbeled* arch also eliminates the heavy lintel needed for a wide space between supports, but is not a true arch. The ordinary gable, which is used mainly with wood and steel, can be made of stone to span a space with two short slanting members instead of one long horizontal member and so provide a pitched roof; it only partially eliminates the tension that limits the span of a lintel in stone.

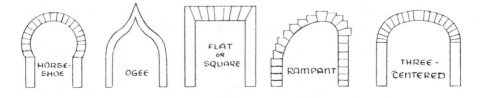

The *round* arch does transmit the downward force of the keystone and the load it supports to the columns, with a minimum of tension. There is, however, a lateral thrust from the arch, which may be counteracted by the corresponding thrust of an adjacent arch or by a sufficiently heavy buttress or wall.

In constructing an arch, a temporary support called centering is used to support the stone until, with the placing of the keystone, it becomes self-supporting. The same centering can be used for more than one arch. To save constructing centering from the ground up, projecting stones sometimes are placed at or near the springing of the arch, to support the minimum centering needed for the arch.

Great spans are possible with the round arch, limited by the compression strength of the material. The principle of the arch has some thirty-five applications, a few of which are illustrated on page 133.

Vault and Dome

The principles of the arch apply to the vault and the dome, used for roofing areas. The dome, a hemispherical vault, when supported by a circular wall transmits its weight to the foundations evenly along the entire wall. Its weight over

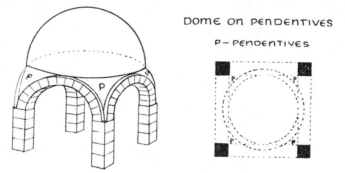

DOME ON PENDENTIVES

P – PENDENTIVES

doors and other openings in the wall can be carried by arches. Some Roman domes were built with a skeleton of brick ribs that required less and lighter centering and provided a lighter and more easily constructed dome.

The *dome* set on a circular base, as in the Pantheon in Rome, has the disadvantage of being difficult or impossible to use in connection with other domes, half-domes, and vaults on rectangular bases. Byzantine builders used a system which divided the weight of a dome among four piers forming a square base. The weight of the dome is carried to the four piers by means of four arches and

four intervening pendentives—triangular segments of a sphere set between the arches.

The *tunnel* vault, also called barrel or wagon vault (A, below), is an extension of the arch in depth; the space it will roof is limited in width but may be as long as desired. If the tunnel vault is supported by an arcade (a series of adjoining arches) instead of a solid wall (as in B), parallel tunnel vaults on arcades (as in C) will permit increase in the width of the space that may be roofed. In another use of the tunnel vault, employed by Roman architects, a tunnel vault is made to intersect a series of parallel adjoining tunnel vaults at right angles (as in D). The right-angle intersection of two tunnel vaults forms a *groin vault*, so named for the groin—the line of intersection.

By transmitting the thrust of the vault to four columns or piers and joining one groin vault to another, more flexible planning of floor space is possible.

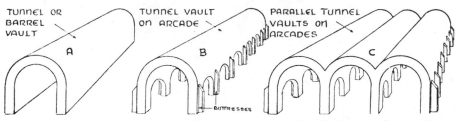

And building is more economical because one bay (vaulted section) at a time can be constructed using the same centering over and over again.

The introduction of *ribs* to mark the groins and the side arches of the vault is indicative of a different concept of vault construction, one in which the linear divisions, rather than the intervening surfaces, form the starting point of the structural design. The resultant flexibility in form, as well as possible structural advantages in the use of the rib, had important consequences for architecture.

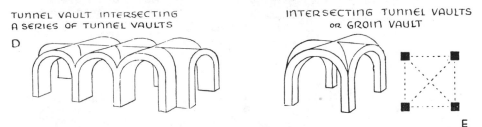

When the arches of a groin vault over a square bay are made semicircular, the

lateral arches are of one height while the transverse arches must be of a greater height because they span a greater space (as in II, below). When the bay is rectangular, there are semicircular arches of three heights forming a domical vault (III), and since the lowest arch parallels the side of the building in order to allow height inside, it follows that these low side arches afford small window space and thus limit illumination for the upper part of the vault. The pointed-arch system of construction makes it possible to bring all the arches to nearly the same height (IV), permitting windows reaching nearly to the top of the vault. A final development in the pointed-arch vault continues the piers supporting the narrowest arch up higher than those of the other arches, leaving less vertical span for the arch to make from its higher springing point. This stilting of the nar-

RIBBED VAULT CONSTRUCTION

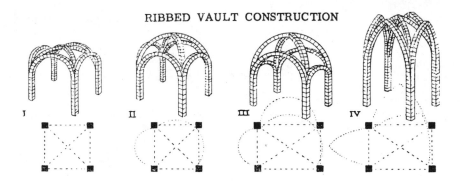

row side arch makes possible large clerestory windows under an arch that reaches to the top of the vault without being unduly narrow and pointed. It permits the greatest flexibility in planning, since longer, narrower rectangular bays may be used, as is shown in the plan of Chartres cathedral.

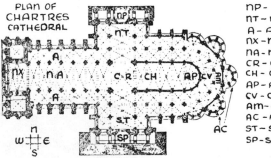

PLAN OF CHARTRES CATHEDRAL

NP – NORTH PORCH
NT – NORTH TRANSEPT
A – AISLES
NX – NARTHEX
NA – NAVE
CR – CROSSING
CH – CHOIR
AP – APSE
CV – CHEVET
AM – AMBULATORY
AC – APSIDAL CHAPELS
ST – SOUTH TRANSEPT
SP – SOUTH PORCH

Some Modern Techniques and Materials

Ferroconcrete or reinforced concrete uses in combination the strength of steel in tension and the strength of concrete under compression. The principles of reinforcing concrete are indicated in the diagram; the tensile strength of iron or steel in rod, bar, mesh, or other form is introduced in the areas of tension, where concrete by itself is weakest. The modern use of steel, concrete, and ferroconcrete in building makes use of older construction techniques, especially the post and lintel.

The *cantilever* and the *truss* are techniques especially suited to the use of steel, although sometimes used in conjunction with wood and other materials, particularly in the reinforced-concrete cantilever. The principle of the truss makes

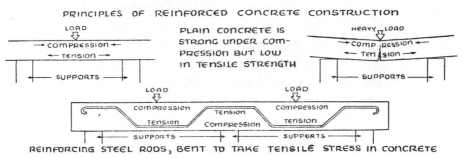

PRINCIPLES OF REINFORCED CONCRETE CONSTRUCTION

REINFORCING STEEL RODS, BENT TO TAKE TENSILE STRESS IN CONCRETE

use of the combination of tensile and compressive strength of steel to form a rigid frame for spanning an opening or space. Bridges, industrial plants, and airplane hangars afford principal examples of its use, and it is related to braced-frame construction in wooden houses. The cantilever principle allows a portion of beam or floor to project beyond the points of support. It requires enough tensile strength in the material to withstand the load on the cantilevered segment,

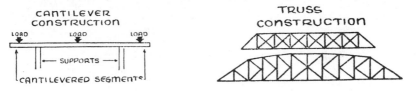

which load is counterbalanced by the load on the other side of the point of support. A common illustration is found in the floors and beams of modern buildings whose main supporting posts are placed some distance inside the wall screen, where they do not interfere with continuous windows.

Many large modern buildings are constructed on the principle of a rigid *steel cage*, a method developed in the late nineteenth century. The self-sufficient frame of the building is independent of the inclosing walls which serve as a kind of skin affixed to the frame. This skin may be of brick, slabs of stone, metal, ceramic or any other thin rigid material, very often glass. Such a building is the exact antithesis of traditional construction in which walls or columns or both supported the building and expressed the principle of structure.

Planning a Building

An architect formulates his building through drawings and occasionally scale models. In general, the drawings, once beyond the stage of sketches, are of three kinds: a *perspective view*, *ground plans* and *elevations*. Whether made to convince a client or to visualize the building more clearly for himself, the architect's renderings have often been handsome works of art in themselves. Often they give a useful clue to how the architect has thought about space and to what aspect of the building he has given greatest attention. Both ground plans and elevations are drawn to an established scale in order to indicate the actual dimensions and proportions. The ground plan indicates the disposition of structural elements on a plane parallel to the ground and an elevation shows the features on a vertical plane without regard to perspective or foreshortening. At times the architect makes clear the relationship of parts by means of a *section drawing*, which is a rendering of the forms as cut through at a given point by a vertical plane. In order to make these drawings readily intelligible, standard methods are used to indicate structural walls, openings, overhangs, etc. These drawings are chiefly means for planning and visualizing the structure. Before actual construction can be begun, detailed technical drawings must be made for every aspect of the structure, from electrical circuits to hardware.

5. THE ARTIST AND THE WORK OF ART

Works of art do not spring into being as isolated phenomena but are created as part of normal human activity, reflecting the judgments, the taste, the human evaluations of the artist who conceived them and often of the time of which they are a part. Although in the study of works of art there is, of course, the danger of becoming so concerned with biography and the historical moment that the fresh direct experience of the work (with which we have thus far been concerned in this book) is lost, a greater knowledge of an artist's production can sharpen our awareness of the subtleties of his vocabulary and often reveal new content which to our direct view may not have been accessible.

The two paintings of the Crucifixion that we compared at the beginning of the book obviously revealed two very different points of view toward the subject, just as they evoked very different reactions in the observer. This difference was by no means a matter of chance or simply caprice; it had its roots deep in the minds and personalities of the artists. Other paintings of Perugino have certain qualities similar to those in "The Crucifixion with Saints," and we would tend to group them as a family of works which within our experience would stand for Perugino, quite apart from any historical information we might glean about the man. Variation, to be sure, would exist; Perugino does not paint an active scene with quite the same measured calm as he painted the Crucifixion. Yet in spite of variations in subject matter and slight changes in technical procedure, there remains a quality that we identify with the sensibility peculiar to Perugino. And so it is with all great painters, painters who are strong enough to have a point of view and message of their own and resist being blown like feathers in the wind

of passing fashion. The peculiar formal handling of Perugino was not, then, just a matter of "style" in the superficial sense of the word, a mannerism by which we might identify the artist. In our analysis we found that the nature of the visual aspect of the works was inseparable from their meaning. What might be thoughtlessly regarded simply as Perugino's style is in truth a key to his outlook, a part of his contribution to artistic content. In this sense, the word "style" is enriched to mean not only the "handwriting" but also a part of the content of the work itself.

But then the question arises, How much of the artist's style is his own, and how much does it simply hold in common with the time? Perugino was not the only Umbrian artist to paint generally in this fashion; in fact, Raphael at one time adopted a very similar formal language. Just as we speak of the styles of different artists, it is also common to speak of the styles of places and times. Thus once we begin seeing a work in its art-historical context, the relationships become complex. Crivelli, for example, belonged to a North Italian school ("school" refers not to an institution but to a stylistic category) of the early Renaissance, while Perugino was of the Umbrian school of the same period. With regard to a work of either we might ask many questions. How does it relate to other works by the same painter? What does it have in common or how does it diverge from work of the same school? How does it relate generally to works of the same time; and how generally are the works of this time similar to or different from the works of another period, for example, Italian works of the thirteenth century? While the search for the answers to such questions could, on the one hand, carry us far away from the work we are considering, it might, on the other hand, also clarify the unique quality of the work and render more profound its meaning.

Before beginning to study the complex fabric of the history of art with its intricate relationships of artists and times, two questions seem particularly appropriate. How best can we describe those qualities that seem to be most profoundly related to a particular artist? How did the artist set about establishing these qualities which he made his own? As an example we shall consider these questions in regard to the work of the French painter Jacques Louis David, who was the dominant European painter at the end of the eighteenth and the beginning of the nineteenth century.

In 1748, the year in which David was born, a reigning painter of France was François Boucher, whose exuberant paintings set the pace for both monumental painting and more intimate decorative genre. His was the kind of painting that

David in growing up was most conscious of, and it was this kind of painting that quite probably David himself planned to continue. In view of this fact it is interesting to compare a painting executed in his early maturity, in 1784 (Fig. 24), with a work by Boucher, "The Triumph of Venus" (Fig. 25), executed, incidentally, in the very year of David's birth. The divergence is certainly startling. An important change has evidently taken place in David's thinking.

Probably the most notable difference, which strikes the eye at once, is one of movement. Boucher's line is a rolling, active one that builds itself into moving, active forms. And the forms themselves merge into the flowing continuous pattern that carries us along, in and out of space, around and over forms, through the entire painting. The path of movement is like a swirling spiral that fades and reappears as it lures us through the sun-shot atmosphere. There is something gay and relaxing about the continuous movement, and we are invited to lose ourselves in the pleasurable rhythm because there is no stopping point that would permit us to withdraw. None of the colors are harsh; all are light and intermediary, blending more than they contrast. In almost every area several hues merge to suggest the soft reflections of light and to link more closely part to part. The red stripes in the floating banner are varied so intricately in value and hue that at points they seem to be engulfed entirely by the warm light. The evident brush strokes which follow the dominant rhythm make us feel that we are joining directly with the artist in the enjoyment of this special world. And it is a quite special world, devoid of the weight and substance of material things while retaining the joys of sense. It is as though sense were sublimated to a realm in which only the enticing nuance, elegance of manner, and unending delight had the importance of reality.

The painting by David offers a far more sober experience. There is motion, to be sure, but the motion is constantly arrested as if to give the viewer time to study the forceful but stable shape of the whole and the weight and substance of every part. The three figures on the left thrust back, then forward, only to be met by the counterthrust of the elderly man holding the swords. The movements are, indeed, thrusts, not light, rolling plays of line. It is as if two forces met and, meeting, created an image at once moving and static. Rather than taking sides by associating ourselves with any one line of movement, we draw back to observe the whole, sensing the action without in any simple sense identifying ourselves with it. Much of the forcefulness of the action depends on the solidity of the forms, which have all the weight of marble and are quite as earth-bound as those

of Boucher are airy. Instead of obscuring the substance of nature, every muscle is drawn in harsh clarity that emphasizes precisely that tactile, volumetric aspect of nature which Boucher preferred to soften or pass by. Even the softer lines of the monumental group of grief-stricken women at the right have a clarity of direction and termination consistent with those of the more forceful figures. The light, far from helping to blend form with form as in the Boucher, gives a greater sense of autonomy to the active elements of the design. Each part seems to exist in its own right. Even from the black-and-white reproduction, a different use of color is suggested. Every shape has its own hue; there is no merging of colors. And the red is not a nuance of red but saturated, solid red. The blue is a solid, sober blue. Finally, the whole starkly illuminated company is framed securely in the three simple arches of the positive, defined background.

What lies behind this great change that has taken place in one generation? Was it unique with David, or did he simply follow the changes of his time? What actually was David saying that was new, and what did it signify?

Although when David decided to become a painter he studied with an artist, Joseph-Marie Vien, who was becoming impatient with the too exuberant art of his time, David seems to have persisted in looking with favor on the art of Boucher and the younger painter Fragonard. In fact, when he tried unsuccessfully for the Rome Prize in 1771, he submitted a painting, "The Combat of Minerva and Mars" (Fig. 26), that has many of the characteristics of the painting by Boucher, characteristics that were the common property of many popular painters of the day. The obvious brush strokes follow the rhythmic motion of the forms, and the forms revolve in an effort at that continuity which gives life and unity to the work of Boucher and to the delightful fantasies of Fragonard. A sweeping curve spirals from the figure of Mars on the left across and up into the sky where Venus floats lightly on a blanket of clouds. But grace seems to be a struggle for David. There is something harsh and solid about the form of the fallen Mars, and triumphant Minerva treads the earth with a heavy step. Looking back from the painting (Fig. 24) of fourteen years later, however, we can see this disrupting ponderosity not so much as a mistake as the beginning of a formal content which will become dominant in David's work. But how did David discover his own vision and slough off what had first charmed him?

In 1774, after several tries, David won the desirable Rome Prize, which started him on five years of study in Italy. There he was tremendously impressed with the works of earlier Italian masters, an art more sober and monumental than

that which had heretofore interested him. And in Rome, where antique art was much discussed and the continuing excavations at Pompeii furnished exciting news, he began, as painters had for two centuries before him, to draw from the monuments of antique sculpture. These were years of study rather than of painting, and it was not until he returned to Paris in 1780 that he began seriously to work on large paintings. When he did begin, however, his manner of working showed much change. Compare, for example, the painting he submitted to the Academy of Fine Arts as his reception piece in 1783, "Andromache Mourning by the Body of Hector" (Fig. 27), with the early student effort, "The Combat of Minerva and Mars."

The structure of the later picture is curiously rigid; almost every line of the simple background and the furnishings is strictly horizontal or vertical, imprisoning the figure of the mourning Andromache in an immobile frame. Neither through soft and brushy forms nor through continuous rhythmic lines can we escape the solid existence of the objects. It is as though the intruding brusqueness of the isolated, outstretched hand of Mars in the earlier work had become the key to a whole composition. The extended hand of Andromache is a moving, eloquent gesture provided for by the carefully spaced forms. And compare its flat, clear silhouette with the soft curving lines of the hand of Minerva. Like other major lines of the painting, the arm is an exact horizontal and takes its place in the strict marshaling of planes parallel to the plane of the picture. The flattening of the space by this parallel arrangement makes each shape count to the full.

From this simple but rigorous composition is produced a strange effect of timelessness. Each element is so exactly placed that it would be hard to imagine the action that preceded and the action that will follow this moment. It is at a point of perfect equilibrium that David has fixed the elements of his drama so that the bold design will make a single impact, sufficiently clear to carry the full emotional significance of the scene. We do not follow the action as in a play, but we sense at once the significance of the action from this tense and poised image. It is interesting to note that the intruding element in this painting is the remnant of David's earlier style to be seen in the rather complicated drapery and somewhat fussy detail. This intrusion is no longer to be noted in "The Oath of the Horatii," the painting we first examined, which David exhibited to the public in Paris in 1785.

The revival of Corneille's affecting play "Les Horaces" in Paris in 1782 won considerable acclaim and moved David to decide to paint a picture on the theme

of the drama. The court became interested and commissioned him to execute a large painting of the subject. The story, from legendary Roman history, concerns a decisive duel during the war of Rome with Alba Longa between three brothers of the Horatii and three brothers of the Curatii, all friends. Although two of the Horatii are killed, the third succeeds in slaying all three of his opponents. On his triumphal return, his sister, in anguish because one of the Curatii slain was her lover, curses him. In righteous anger the triumphant Horatius kills her. According to one version of the story, which David found elsewhere than in the play of Corneille, Horatius is condemned to death for this rash act but is absolved by the acclamation of the public, which recognizes his steadfast patriotism, stronger even than family ties. It was such a scene that David initially intended to paint, showing the aged father pleading for the life of his proud son, but he discarded it in the search for a pictorial image that would in itself be powerful and less dependent on a literary argument. The oath of the Horatii prior to combat as David formulated the incident—it is not a part of the play or of ancient accounts—is just such an image.

To capture the full atmosphere of the scene, David felt that he must return to Rome, and there, over a period of some eleven months, the painting was executed. This time David knew well what Rome meant to him. He found there in the antique sculptures and monuments a heroic simplicity that freed him from the now hateful elegant, light, and winsome effects in painting which he had once admired. Every form in the "Horatii" expresses an earnestness and seriousness quite beyond the capacities of the earlier manner. In a fixed image of almost hypnotic power, David stirs us with a sense of heroic purpose.

Because David drew support for the creation of this new vision from the works of classical antiquity, the new style for which he became famous has been called "neoclassical." But David was neither the only person of his time nor by any means the first to draw inspiration from antiquity. How much, then, of this vigorous statement of David's is peculiarly his own; how much does he share with others who had an equal interest in classical literature and art?

At the time David was engrossed in his Roman studies, an English sculptor and draftsman was developing an art based on the antique which was also to find favor throughout the world. This was John Flaxman, whose illustrations to Homer and other ancient authors and whose designs for the ceramic ware of Josiah Wedgwood made him famous. But Flaxman emphasized a different quality that he found in Greek and Roman sculpture, a quality the German

theorist and antiquarian Winckelmann had earlier extolled. Even when Flaxman is most like David, as in his design of the oath from "Seven Chiefs against Thebes" (Fig. 28), there is a quite distinct fluid rhythm of line and a grace of repetition. He attempted to show each natural form in its most perfect rhythmical state, in its "ideal" aspect. As a result there is little sense of physical contact, and all is softened by a prevailing effect of harmony. In such a utopia based on grace, even battles make little noise.

A comparison with David makes clear the fact that each believed in clarity as opposed to vagueness of form and contour; in simplicity as opposed to the complexities evolved from shifting light, complicated spatial compositions, and confusingly irregular shapes; and in the use of antique subject matter. But David combines the clarity and simplicity with a matter-of-factness of vision quite different from the ideality of a man like Flaxman. David carried his sense of the positive and the clear in art to his vision of the actual world, as the gnarled musculature and the firmly sculptured forms of the Horatii testify. Part of the characteristic power of David lies in the fusion of two quite opposing elements that we noted on first looking at his painting: a rigorous and imposing organization of artistic form and a candid view of nature. One might suppose that a candid view of nature would result in a composition rather free from rational contrivance, dictated by nature itself, or that an architecturally constructed composition would dictate forms strongly simplified and abstracted from nature. But David seemed unwilling or incapable of escaping in his art to an ideal world of perfect order without carrying the world of weight and substance with him. As a result, he tried to impose on the forms of the material world itself the rational clarity and order that some might reserve for a utopian dream.

Such an attitude has implications extending far beyond the boundaries of art. It is hardly surprising that David's paintings with their forthright style and heroic implications should be heralded as symbols by the new social order in France. David himself identified his earnest attitude toward art with his view of society and looked upon his painting as having a positive social purpose. In a report he read to the French Convention in November, 1793, he said: "The arts must then contribute forcefully to the education of the public. Too long have tyrants, afraid even of the image of virtue, kept thought itself in chains, encouraged license, and stamped out genius. . . ." In the twofold way in which, he believed, the arts affected the public, his sober forms, freed from the caprice and "licentiousness" of Boucher's once attractive style, were important. "The arts

are the imitation of nature in her most beautiful and perfect form," he said, "and a feeling natural to man attracts him to the same end. . . ." Beautiful and ordered form can thus strengthen man's natural tendencies toward good and moral conduct. But this serious, "noble" form in art must be associated with great human actions. "Then," said David, "will those marks of heroism and civic virtue offered the eyes of the people electrify their soul and plant the seeds of glory and devotion to their fatherland."

David was made a member of the revolutionary Convention, served as a powerful member of the Committee on Public Education, and joined in voting for the death of the king. As a painter and designer he was of tremendous influence, having created in his work the symbol of the Revolution. Young painters flocked to his studio; fashions in furnishings and dress were inspired by his paintings; and the organization of state pageants was entrusted to his care. All this helped to identify the new "classical" style with the new social outlook of France.

Of the works painted at this time, probably one executed at the behest of the government in 1793 most forcefully illustrates David's peculiar power of creating moving, dramatic symbols without losing contact with the material world. In July, 1793, the ailing revolutionary Marat was killed by Charlotte Corday. Aroused to bring the name of Marat forcefully to the public, David decided to show him under the circumstances in which he had seen him the day before his murder—in his bath, where he was writing out his thoughts for the good of the people. Such a situation would seem hardly a heroic one; yet David's painting (Fig. 29), shown to the public in October of the same year, made the politically dubious Marat a hero.

It was no longer necessary for David to refer to classical subject matter; Marat is represented quite literally. It is by force of composition alone that David makes an ordinary incident important. The inanimate objects—the tub, the drape, and the block of yellowish wood—are painted with a relentless clarity and specificity. Their hard vertical and horizontal forms are fixed in a scheme of measured proportion in the lower half of the great void rectangular space that reveals neither setting nor time of day. In this stark framework is mounted the inert, pathetic form of Marat. Although the body furnishes the only really rounded forms in the rectangular composition, they are not fluent and harmonious as the forms of, for example, Flaxman. In fact, there is no gentle harmony or soft patterning of color to mitigate the intensity of the image. Here, more than in any of the earlier works, David has realized the power of constructing simply

with isolated, autonomous forms—a principle of opposition and contrast rather than of confluence and continuity. How sensitive he had become to the adjustment of forms to space may be judged by covering a part of the seemingly "meaningless" space at the top of the painting. The character of the painting changes completely. It is the difference between simply the painting of a dead man in a bath tub and the portrayal of heroic death.

David's painting should not be construed as simply the illustration of, or propaganda for, a political theory. Actually David knew very little about politics as such but put his faith in men who seemed to him heroes. These men he saw as rising above the ordinary world by force of character yet being very much of the world. Napoleon he welcomed as both Consul and Emperor, and made no basic change in his thinking to do so. Using his eloquent pictorial means he created a symbol of Napoleon much as he had done earlier for the Revolution. What is perhaps his finest portrait of Napoleon shows the General on a rearing horse at the St. Bernard Pass. A rearing horse, to judge from the other paintings we have seen of David, would seem to present a complicated problem: what is more shifting in its motion than a rearing horse? The painting (Fig. 30) has sometimes been criticized because the horse does not really seem to go anywhere, but such comment shows an ignorance of David's special content. As in marshaling the figures in "The Oath of the Horatii," David has pitted one form against another so that each, although in itself forceful, counteracts the other, creating again an image that has the tension of life but is fixed, immobile, in a monumental equilibrium. How better could a painter express the vision desired by Napoleon when he said, "Paint me calm on a furious steed."

But David did not spend his whole time painting monumental canvases. Among his finest works are his simple portraits. In these he shows particularly the candor of vision, the freedom from stylistic caprices and artful touches, that he had struggled (against his initial environment) to achieve. The portrait of the Countess Daru (Fig. 31), for example, has the clarity of volume, the fulness of form, and the freshness of view that were important elements in his more elaborate constructions. Rather than emphasize the winsome effect of graceful lines and continuous rhythms, he composes the painting with the same sort of rigid interior structure as in his more heroic works, giving the figure an air of individual existence in its space which in a more gracious scheme might be lost. In this respect, it is interesting to compare the portrait with one painted during the same decade by one of David's own pupils, J. A. D. Ingres (Fig. 32), which shares the

clarity and classical interest but lacks the hearty appraisal of material basic to David.

These few paintings do not by any means illustrate the full complexity of David's work, even through the early part of his life, nor do they show all the subtle variations in his development. What they do show is that a painter evolves his style, his particular artistic vision, as he evolves his ideas about art, life, and nature, over a period of years, taking from his environment what is serviceable to him and rejecting what is not. In the case of David, the style he evolved gave a special content to whatever he depicted and was even associated with a particular social outlook as well as with a view of nature.

But in comparing the work of David to that of others such as Flaxman, who worked in the popular "neoclassical" manner of the time, the need for clarifying with great care just what we mean by the style of an artist becomes apparent. To call David simply "neoclassical" would be to neglect those qualities which were so much his own. Even to generalize too freely about the work of David himself would be to ignore the meaningful distinctions that separate the sparklingly present portrait of Mme Daru, painted freshly from nature, from the portrait of Napoleon, so ably constructed in accordance with the artist's sure dramatic sense. Yet a knowledge of these broader relationships can add much to our enjoyment of the works. A knowledge of the art from which David departed, an acquaintance with the work that his contemporaries with similar sympathies created, and the recognition of recurrent basic qualities of the artist in a variety of works—all may contribute to a deeper and more sympathetic response to any one of his paintings.

One final biographical note might be added. David continued as court painter to Napoleon, recording his coronation and other major events in huge paintings until Napoleon's ultimate defeat in 1814. The final painting he completed under the inspiration of Napoleon was finished only at the time of the General's return from Elba. It showed Leonidas before the battle of Thermopylae. On the reestablishment of the monarchy, David, who had voted for the death of Louis XVI as a member of the Convention, went into exile in Brussels, where he remained until his death in 1825. His students and followers continued to dominate in France, however, for many years, and the influence of his achievement continued throughout Europe.

6. THE EYE AND THE MIND

Although it seems never seriously to have been doubted earlier that the artist's task was to create that which otherwise had not been seen, a strange current developed in the nineteenth century that judged art in accordance with how closely it looked like something seen in nature. The word "realistic" is a vestige of the simple belief that reality could be had for the seeing. No one of this belief seemed to doubt that seeing was a straightforward proof of fact. To be sure, "the study of nature" had been the forming principle of many artists over the past four or more centuries, but this meant many different things; for example, it could mean ignoring the particular for an essential, "more natural," ideal beauty; classifying distinctive physical types and facial expressions; or conscientiously rendering every perceivable detail of a carefully studied object. But what developed now was an art of direct perception in which an artist attempted to restrict himself to recording only that which he could see at the moment. There is a vast difference between knowing the form of an object from past experience and extended examination and seeing the object in its momentary environment as if never seen before, affected by the particular light and surrounding shapes and colors. The artists, fascinated with this immediate perception, tried to push memory aside in order to see everything with a fresh eye. What they arrived at was not always the image that the public regarded as reality. The ultimate point in the development of this concept, which has its beginnings in the early years of the nineteenth century, was reached by some of the painters, such as Claude Monet, who exhibited together in Paris in the 1870's. They were dubbed "impressionists" and much ridiculed for having lost

contact with "reality." Yet by the early years of the twentieth century, catching the perceived effect—an obsession that even invaded sculpture—had become the widely accepted, though rather thoughtless, goal of the greater number of artists.

To free the eye from traditional formal preconceptions was a notable step, but once the relationship between eye and mind was considered not fixed but subject to investigation, there was no reason to suppose that the more venturesome artists would be content with what they came to consider mindless perception, in which the eye never challenged the mind. Most were unwilling to give up the wide range of perceptions of which they were now aware—particularly the greatly expanded gamut of color—yet they needed also to satisfy the creative urge of the mind. In place of an art that was content to bask in the pleasures of sight provided by nature, they wanted an art that, as one critic said, stimulated the mind to the point of creativity.

In a sense, this is what we have been discussing through much of this book. The smooth regularity of the Perugino moved the mind to ruminate in a particular way, as did the agitated forms and unsettling color of the "Crucifixion" by Crivelli. For all its close attention to anatomic detail, David's "The Dead Marat" carried perception directly to the brooding mind through the strength of its form. But in all the cited examples, except the sculpture by Max Bill, the formal evocation is so completely identified with the incident and the objects represented that thought and perception become one. In a way that is true as well of Max Bill's "Tripartite Unity." The intellectual problem—three in one— is both posed and solved by the persuasive forms; there is no conflict between perception and idea, and the mind is left at peace with the continuous harmony of thought and perception.

The mind, however, is not a very tractable organism. In spite of our most reasoned efforts it tends often to seek refreshment in uncontrolled chaos. Many centuries ago it was recognized that art, in bringing order to the senses, could serve to temper the mind through a reciprocal interplay: the mind imposed order on the sensuous environment, and the senses, thus well ordered, presented the mind with a tangible paradigm of harmonic perfection. This instructive aspect of art could be and was manifest through all activities subject to design, from dance to the planting of gardens. The resultant harmony of man's inner and outer worlds was generally discussed in abstract, cosmic terms. Art provided

the means for transcending the chaos of the physical world, providing a glimpse of a more perfect order.

Even the work of Max Bill serves such a function, as do many works created in the twentieth century which use the concentration on clear—usually starkly simple—form and color alone to create live but subtle harmonies with which to entrance the mind. This is a kind of contemplative art which, in focusing our thoughts and feelings, shuts out for a moment the rampant extension of both sense and imagination. Architecture, too, has responded to this principle. Shorn of all associative elements—cornices, classical orders, and picturesque references to exotic countries—it has depended on forms and spaces that are in themselves satisfying to the eye and mind. Awakened perception, roused by a new vision of nature, eventually made possible a renewed language of art.

If form can convince the mind to live in harmony, it can also, as we have seen, provoke a moving disharmony and play, in fact, on the mind's consciousness of potential chaos. Resorting to a kind of simple sign language we might say, "Yesterday I felt ⊙ , but the day before I felt ⚡ ." The general meaning would be clear. The difference, however, between these little spontaneous drawings is more than in just the jocular evocation of mood. It has to do with our continued feelings as we look at the forms, simple as they are. The first form is self-contained and tends to gather attention into itself; it is satisfyingly complete. The second form, on the contrary, sets up an activity that refuses to settle down; rather than being complete in the sense of the other form, it exists in a kind of continuing present. A similar kind of distinction pertains between some works of art.

Neither a work by Piet Mondrian (Fig. 33) or Wassily Kandinsky (Fig. 34) refers to natural objects or incident, yet they have their distinctive content because of the way they make us feel and think. Even though they both might be called abstract because they do not relate directly to the natural environment, each is very specific in the character of experience it provides. When looked at intently, each isolated line of the Mondrian becomes a force countered by others to form a tense but satisfying equilibrium. In every one of his paintings of this kind, the struggle between harmony and disharmony is dramatically fought, with harmony always the sure but precarious victor. A sense of harmony is not a given factor but must be achieved, Mondrian indicates, and the act of achievement for Mondrian was indivisibly both an aesthetic and spiritual act.

Kandinsky was no less concerned with the spiritual aspect of art than Mondrian, but his energetic, explosive forms are hardly conducive to a sense of cosmic equilibrium. A seemingly physical identification with his active lines is almost inescapable, to the degree that we tend less to judge the painting than to become a part of it. Not contemplation but headlong participation seems key to the experience until the distance between viewer and the painting viewed disappears. Using all means for his sensuous assalt—vivid color, bold line, entangling form—Kandinsky sets out to turn that which is most patently physical into intense emotion and ultimately into an ecstasy of spirit. To do this, he strongly believed that all ties to likeness or recognizable incident had to be severed. The world of sense was synthesized in the painting, which provided in itself a kind of physical transcendence.

Unlike Mondrian and Kandinsky and the many artists who have up to the present considered the forms of the work of art in themselves the catalysts for experience, many artists have not been content to give up references to commonly recognizable objects, yet in no sense have they wanted to perpetuate the idea that the perceiving eye is all. In Picasso's study of a figure (Fig. 35) the substantial form of a human being is immediately identifiable; to pretend to overlook it in order to talk about the play of forms or abstract plastic values is only self-deluding. A human figure it is, and once we recognize our own kind— as distinct from a tree, a mountain, or a barn—our whole perception changes since we assume the existence of certain creatural qualities we know from internal experience. But Picasso's figure is hard to keep in conceptual focus. A leg is painted as a convincing round volume only suddenly to change to a lively two-dimensional shape; the well-established torso disconcertingly fails to support the arms; some forms are treated as if to be looked at, others as if they were meant to be acted out. There is a struggle between what we assume the figure to be and what happens as we look at it. And it is evident that no amount of looking or squinting is going to bring together what the mind recognizes and the eye sees. There is a persistent and lively tension between knowing and seeing that casts a useful doubt on the whole matter of simple perception.

Picasso pushed this tension much further in paintings such as the portrait of the critic and dealer Daniel-Henry Kahnweiler (Fig. 36). At first glance the largely neutral-toned painting seems like only a formal ordering of straight lines shading in and out of an indefinite space. But out of this busy complex

of mostly vertical, diagonal, and horizontal lines—some of which extend into planes—emerges the solemn image of a man posed as in a formal, hieratic photograph. Where is the figure? That is a good question. Although he seems surely to be there, there is not a single shape that describes a human feature. In fact, the lines are resolutely geometric, seeming intent on their own activity, and the warm and cool interplay of almost neutral color is uniform throughout. Yet once the image is sensed it will not go away. The answer to the "where?" is that the figure exists somewhere between the picture and the viewer, being the collaborative product of the active eye and the remembering, formulating mind. The viewer has become an active participant with the artist in reconciling the perception of artistic form with the perception of objects in nature without either perception merging with the other. This is a totally different kind of experience from either that provided by Mondrian or Kandinsky, or by the smooth rhythms of Max Bill. Rather than a retreat from the world of things, Picasso's painting draws its strength from our habits of recognition, yet never allows recognition to overcome the direct perception of the active artistic forms.

In such paintings Picasso created an active counterpoint between the artistic structure and the recognizable forms of nature, and in so doing engaged an irrepressible area of the mind, the memory. The philosopher Henri Bergson once asserted that to see is only an excuse to remember; Picasso's hints at objects and people not only spur the course of recollection but, since the hints are no more than that and the exact confines of the object are not to be realized, the imagination is left free to continue to speculate. Is there a glass on the table? A bottle? Although the forms of the painting may create a stable composition, the amiable opposition of form and image makes the work not a static design but a continuing, exploratory experience.

Only a slight hint is enough to activate the associative faculties of the mind, and the nature of the suggestion may be of an unexpected sort. Picasso and others used words, musical notes and conventional signs as well as fragments of recognizable objects to bridge the gap between the freely constructed design and the remembered environment. The greater the distance between the pictorial structure and the image evoked, the more powerful was the effect of surprise and wit. There is something both funny and mysterious about a seemingly random collection of pasted paper and geometric lines that we persist in seeing as a man in a stiff hat (Fig. 37), even though no feature is specifically depicted.

Although this often witty counterpoint can be carried out effectively with reference to any group of objects—still life arrangements became a continuing theme—the hint of a living creature quite changes our reaction to the situation. We are basically egocentric beings and tend to delight in seeing our inner vitality reflected in the world around us. We take pleasure in detecting animal figures in the grain of wood and discovering faces in the clouds. Undeniably, as we have discussed, some combinations of forms unrelated to beings, can in themselves create actions which we find interesting and at times emotionally provocative. They might be as simple as two interlocking rectilinear forms 🔲 or a smoothly rolling line ✏️ . Such compositions can be discussed readily in terms of the implied relationship between the forms themselves or as providing a kind of lyrical continuity. But supposing there are additions: 🔲 ✏️ . Although the additions could hardly be considered as creating likeness, they have totally changed our way of seeing the forms. The formal activity is still there but must now be considered within the context of creatural life. In such a situation, all of the sensuous impact, which might include color, texture, linear activity, etc., plays a new part once this bond of human sympathy is established. Sometimes, as in the Picasso, the effect is humorous, at times the wayward forms can allow us to act out a free fantasy as in the work of Joan Miró, and sometimes the implied humanity peeking through the encumbrance of sense evokes a profound poignancy, as in Paul Klee's "Child Consecrated to Suffering" (Fig. 38). Once a collection of forms or even inanimate objects assume an animate identity, the mind is not likely to let them return to their external, impersonal existence. A new spell has been cast linking the viewer and the outside world.

What we have encountered, then, are three quite different ways by which content is generated in art, all of which share properties with the paintings by Perugino and Crivelli with which we began, and yet are quite distinct. We have been concerned with creating a live sense of order through form that makes the work of art a point of concentration to the exclusion of all extraneous thoughts or feelings; we have noted how the energy of forms and colors, without reference to external things, can excite the mind to plunge it into a world of heightened emotional and spiritual experience; and we have seen how all of these properties can play in counterpoint to the appearance and memory of known objects and beings of the physical world. All of these means have remained a part of our modern perception in art and have even changed the way we look at and discuss

some works from the past.

Of these tendencies in art, probably the most continually provocative has been the last, that dealing with the persistent image. Whether summoned by slight hints or emerging from an assertive artistic context, images of people, places, and things tend to introduce an associative context that has no limits. Although Kandinsky believed that reference to identifiable objects was inhibiting, others have used the adroit reference to objects to open up new reaches of the mind. Not a desire for likeness has motivated the artist so interested, but a fascination with the complexity of thought and perception, made especially evident when the imagery conjured up and the present formal order remain distinct.

One direction that an interest in the mind confronted with unresolved imagery might take—and did—was to explore the mind itself. Deliberately cultivated absurdity, for example, can confuse the rational function of the brain with the intent of revealing other levels of knowing. That there might be other levels in any way commendable was not a wholly modern idea: there have always been religious beliefs that exalted intuition over rationality. But the new interest has not always been inclined to interpret the non-rational as the voice of God. Efforts to surprise the mind into recognizing new values, or no values, have ranged from the chance compositions of the Dadaists in 1916 to the staged "happenings" of the 1960's. Since in the early years of these explorations the work of Sigmund Freud and Carl Jung came to notice, it is not surprising that an elaborate psychological vocabulary was developed for the discussion of the new experiences afforded by art. In the 1920's André Breton and his associates became quite doctrinaire in setting forth the principles by which art dealt with the unconscious, postulating a new reality—a surreality—based on a marriage of the outer world and the deeply imbedded inner world of the mind. Man loves his unconscious mind, insisted Salvador Dali, and the followers of Jung's teachings have associated the deeply rooted responses of the mind to a stratum that runs through all mankind. For such beliefs, logic and rationality must be the antithesis of true human understanding. Thus an enigmatic art can serve as a catalyst for developing a new basis for unity within the human community, a unity—those who believe have hoped—free from dominating systems and public disguises.

But these pursuits, which have been interpreted in terms ranging from the

psychological to the political and the cosmic, although they have had a profound effect on the thinking of artists and their supporters, are not the only result of the revolution in perception. Not every artist, even though acutely aware of the enigma of his art, has wanted to explain it in psychological or philosophical terms. Many have been preoccupied with the images themselves and their unending provocativeness. Questions have often been more important than answers. Artists have gone back repeatedly to the visual paradox in which the work of art questions the relationship between vision and reality. Paradox might be a word applicable to Picasso's "Man with a Hat, ' which clearly to the eye is oddments of pasted paper and a few rigid lines, yet is just as clearly a jaunty human personality. No less a paradox in its way, although totally different in means, is George Segal's "The Subway" (Fig. 39) in which the evident artifice of art and mundane objects from the everyday world come together in stark contrast. At least our mind tells us that the contrast is abrupt and illogical, yet somehow the plaster figure inhabiting an actual setting seems quite at home, absorbed in her own thoughts and actions. Instead of looking for an implied image, we are led by this paradoxically real yet patently unreal situation to examine our consciousness respecting the nature and value of human existence. The unresolvable confrontation of art with life challenges both perception and reasoning and may or may not prompt a philosophical digression. In any case, the challenge thus formulated within the selective boundaries of a sensuously persuasive work of art provides a satisfaction in itself since it brings together in a resistant unity the many divergent tendencies of the mind.

Such a work as Tom Wesselman's "Still Life #24" (Fig. 40) seems so very tangible—so "real"—that we might be tempted to accept it as simply a heroic size, classically organized still life made up of an amusingly unclassical group of objects. It becomes quite evident, however, that the "objects," with the exception of the actual drapery and shade-pull, are really advertising images of the objects—public abstractions—rather than the things themselves. Even the attractive view from the window, a convincing vista in depth, is provided by a travel poster, more promise than actuality. And the luscious ear of corn with its melting pat of butter is molded in thoroughly resistible plastic. Nothing, from the pictured asparagus on the pictured can to the half-peeled banana, conjures up an assuring sense of contact with the thing represented. The initial reality here is not the corn or banana or bottle of salad dressing but the huckster

images belonging to the world of commerce. Out of these second-hand images the lively composition of the painting develops. The looping curves of the plates, the drapery, the aspiring wish-bones, and the assertively baroque Del Monte label coax a jocular manifestation of life from the collection of paper promises. Even the banana peel and the swinging *y* in "Tareyton" take part in the unexpected lyricism. Wesselman has adroitly brought the false—masquerading as real—into the actuality of art, and a delightful work of art at that. But what a problem it poses for anyone who wishes to be "objective." What is real? what is illusion? or is it possible that to recognize illusion is to make a new contact with reality?

The direct and innocent vision once courted in the nineteenth century no longer seems possible, although we might like at times to will ourselves back into a state of visual innocence. The memory of other images and cognitive processes inserts itself, even when viewing the depiction of a single object. We recognize the object's isolation from possible association as a special quality since we see it in relationship to an infinite number of possibilities—merging with space, agonizing in formal stress, as a device for recollecting past experiences, etc. In a reverse of the procedure from early in the century by which the artist delighted in seeing how far he could push the artistic construction and still evoke an image, many artists in the 1970's experimented to see how exactly they could reproduce a likeness and still maintain a questioning relationship between the artistic image with its reverberations in the mind and the physical fact. They summoned the sharp, impersonal eye of the camera to their aid, removing themselves in doing so from any personal involvement with the things seen. The photograph served as an intermediary and in some instances became the subject of the picture, as if the frozen snapshot were reality itself. And this detachment set the stage for the perceptual ambiguity that resulted. Idelle Weber's meticulously painted still life of collected refuse (Fig. 41) glistens and shines with convincing verisimilitude; each object is set forth with dazzling, almost feverish, clarity. The shrewdly organized play of color and form is carefully disguised by the seemingly accidental character of the assembled waste. Yet the more one looks the more conscious he becomes that a distance intervenes to make the thought of direct physical contact impossible. Everything is so near and yet so far, vivid to the sight but imprisoned in the mind. This puzzling quality is made more evident if the painting is compared to a still life

by Henri Fantin-Latour (Fig. 42) from late in the nineteenth century. Here the precise forms existing smartly in the crystalline space are an unquestioned delight to the eye and sharpen our awareness of the precise character of objects around us. Tantalizingly, Idelle Weber's painting suggests that no matter how closely we assess the detail of our surroundings, we remain spectators, isolated from them.

CHRONOLOGICAL TABLE

A CHRONOLOGICAL TABLE PERTAINING TO THE
VISUAL ARTS, LITERATURE, AND MUSIC

	Visual Arts*	Literature	Music
B.C.	Great Pyramid, *ca.* 2700 B.C. Temple at Karnak, *ca.* 1500–330	*Book of the Dead*, 3500– 1500 B.C. *Gilgamesh* epic, *ca.* 2000 *Rigveda*, 1500–500 Bible, 10th or 9th cent. B.C.–*ca.* A.D. 100 (King James Version, A.D. 1611) Homer, *ca.* 9th cent.	
	Assyrian Bull, Palace of Sargon II, *ca.* 722–705 Parthenon, Athens, 447–432 Polyclitus (S), 5th cent. Phidias (S), 490–432 Lysippus (S), 4th cent. Praxiteles (S), 4th cent.	Confucius, *ca.* 550–478 Aeschylus, *ca.* 525–456 Herodotus, *ca.* 484–425 Sophocles, *ca.* 496–406 Euripides, 480–406 Thucydides, *ca.* 471–400 Aristophanes, *ca.* 448–385 Plato, 427–348 Aristotle, 384–322 *Bhagavad-Gita* (in *Maha- bharata*, 200 B.C.–A.D. 200) Lucretius, *ca.* 98–55	Fragmentary remains
	Ara Pacis, Rome, 13–9 Paintings from Herculaeneum and Pompeii, 1st cent. B.C. to A.D. 79	Virgil, 70–19 Horace, 65–8 Ovid, 43 B.C.–A.D. 18	
A.D.	Pantheon, Rome, *ca.* A.D. 130 Manuscript Illustrations, from the 3d cent. Ku Kai-chih, *ca.* 350–*ca.* 410 Christian Mosaics, 4th to 15th cent. Santa Sophia, Constantinople, 532 Wang Wei, 699–759 Wu Tao-tse, 8th cent. Romanesque Architecture in Europe, 11th–12th cents. Sant'Ambrogio, Milan, 11th–12th cents. Chartres Cathedral, 12th–13th cents. Rheims Cathedral, 13th cent. Amiens Cathedral, 13th cent. Santa Croce, Florence, 13th cent. Ma Yuan, 1190–1224 Hsia Kuei, *ca.* 1180–1230 Liang K'ai, *fl.* 1250 Nicolo Pisano (S), *ca.* 1220–1278 Cimabue, 1240–1302 Duccio, *ca.* 1255–1319 Giotto, 1266–1336 Simone Martini, *ca.* 1285–1344	Tacitus, *ca.* A.D. 55–117 Kalidasa, 3d or 4th cent. St. Augustine, 354–430 Boethius, *ca.* 480–524 Koran, *ca.* 650 Bede, 673–735 *Beowulf, ca.* 700 *Kalevala*, before 12th cent. *Song of Roland*, 12th cent. *Cid*, 12th cent. The *Eddas*, 12th–13th cents. Icelandic sagas, 12th–15th cents. Metrical romances, 12th– 15th cents. *Nibelungenlied*, 13th cent. *Volsunga Saga*, 13th cent. Dante, 1265–1321 Petrarch, 1304–1374 Boccaccio, 1313–1375 Chaucer, *ca.* 1340–1400 *Mabinogiôn*, 14th–15th cents.	Church Chants under Pope Gregory, *ca.* 600 Troubadours, 12th–13th cents. Trouvères, 12th–13th cents. Minnesingers, 12th–14th cents. Leoninus, *fl.* 1160 Perotinus, *fl.* 1190 Machaut, *ca.* 1300–1377 Landini, *ca.* 1325–1397

* Architects are identified by "(A)" after their names, sculptors by "(S)" after theirs. Artists with no
symbol after their names are known principally as painters.

	Visual Arts*	Literature	Music
15th Century	Brunelleschi (A), 1377–1446 Ghiberti (S), 1378–1455 Donatello (S), ca. 1386–1466 Fra Angelico, 1387–1455 Jan van Eyck, 1385–1440 Rogier van der Weyden, 1400–1464 Masaccio, 1401–1428 Alberti (A), 1404–1472 Fra Lippo Lippi, 1406–1469 Piero della Francesca, 1416–1492 Memling, ca. 1430–1494 Pollaiuolo, 1433–1498 Mantegna, 1431–1506 Giovanni Bellini, ca. 1430–1516 Verrocchio (S), 1435–1488 Crivelli, (?)1435–ca. 1495 Botticelli, 1444–1510 Perugino, 1446–1523	*Arabian Nights*, 14th–16th cents. Miracle and Mystery plays, 12th–15th cents. Morality plays, 14th–16th cents. Popular ballads, 15th–17th cents. Malory, ca. 1408–1471 Villon, 1431–1489 Lorenzo de Medici, 1449–1492 Poliziano, 1454–1494	Dunstable, ca. 1370–1453 Binchois, ca. 1400–1467 Dufay, ca. 1400–1474 Ockeghem, ca. 1420–1495 Obrecht, ca. 1430–1505 Isaac, ca. 1450–1517 Josquin des Prés, ca. 1450–1521
16th Century	Leonardo da Vinci, 1452–1519 Dürer, 1471–1528 Michelangelo (S), 1475–1564 Giorgione, 1478–1510 Titian, 1477–1576 Altdorfer, 1480–1538 Grünewald, *fl.* 1510 Raphael, 1483–1520 Correggio, 1494–1534 Holbein, 1497–1543 Cellini (S), 1500–1571 Pontormo, 1494–1557 Bronzino, 1503–1572 Tintoretto, 1518–1594 Palladio (A), 1518–1580 P. Brueghel (elder), 1525–1569 Veronese, 1528–1588 El Greco, ca. 1545–1614	Skelton, ca. 1460–1529 Dunbar, ca. 1460–1530 Machiavelli, 1469–1527 Ariosto, 1474–1533 Erasmus, 1466–1536 More, 1478–1535 Michelangelo, 1475–1564 Rabelais, ca. 1490–1553 Ronsard, 1524–1585 Montaigne, 1533–1592 Tasso, 1544–1595 Sidney, 1554–1586 Spenser, ca. 1552–1599 Marlowe, 1564–1593	Senfl, ca. 1492–1555 Jannequin, *fl.* 1529–1559 Gombert, ca. 1495–1560 Willaert, ca. 1480–1562 Arcadelt, ca. 1514–1557 Palestrina, ca. 1525–1594 Philippe de Monte, 1521–1603 Orlando di Lasso, 1530–1594 Merulo, 1533–1604 Victoria, ca. 1549–1611 Marenzio, ca. 1550–1599 G. Gabrieli, 1557–1612
17th Century	A. Carracci, 1560–1609 Caravaggio, ca. 1569–1609 Guido Reni, 1575–1642 Rubens, 1577–1640 Inigo Jones (A), 1573–1652 Hals, 1580–1666 Poussin, 1594–1665 Van Dyck, 1599–1641 Bernini (A & S), 1598–1680 Borromini (A), 1599–1667 Velasquez, 1599–1660 Rembrandt, 1606–1669 Steen, 1626–1679 Vermeer, 1632–1675 Wren (A), 1632–1723 Hobbema, 1638–1709 Watteau, 1684–1721	Cervantes, 1547–1616 Lope da Vega, 1562–1635 Shakespeare, 1564–1616 Bacon, 1561–1626 Donne, 1572–1631 Jonson, 1572–1637 Webster, ca. 1580–1625 Herbert, 1593–1633 Herrick, 1591–1674 Milton, 1608–1674 Calderon, 1600–1681 Corneille, 1606–1684 Molière, 1622–1673 Marvell, 1621–1678 Bunyan, 1628–1688 Dryden, 1631–1700 Racine, 1639–1699 Defoe, ca. 1659–1731 Addison, 1672–1719 Congreve, 1670–1729 Swift, 1667–1745	Gesualdo da Venosa, ca. 1560–1613 Sweelinck, 1562–1621 Byrd, ca. 1542–1623 Morley, 1557–1603 Dowland, 1562–1626 Wilbye, 1574–1638 Weelkes, 1575–1623 Gibbons, 1583–1625 Monteverdi, 1567–1643 Frescobaldi, 1583–1643 Schütz, 1585–1672 Lully, 1632–1687 Buxtehude, 1637–1707 Purcell, 1659–1695 Corelli, 1653–1713 A. Scarlatti, 1659–1725 F. Couperin, 1668–1733 Vivaldi, ca. 1675–1741 J. S. Bach, 1685–1750

162

	Visual Arts*	Literature	Music
18th Century	Tiepolo, 1696–1770	Pope, 1688–1744	D. Scarlatti, 1685–1757
	Chardin, 1699–1779	Voltaire, 1694–1778	Handel, 1685–1759
	Boucher, 1703–1770	J. Rousseau, 1712–1778	Rameau, 1683–1764
	Hogarth, 1697–1764	Fielding, 1707–1754	Pergolesi, 1710–1736
	Gainsborough, 1727–1788	Johnson, 1709–1784	Stamitz, 1717–1757
	Copley, 1737–1815	Goldsmith, 1730–1774	Gluck, 1714–1787
	Houdon (S), 1741–1828	Sheridan, 1751–1816	K. P. E. Bach, 1714–1788
	Stuart, 1755–1828	Lessing, 1729–1781	Haydn, 1732–1809
	Fragonard, 1732–1806	Burns, 1759–1796	Boccherini, 1743–1805
	David, 1748–1825	Blake, 1757–1827	Mozart, 1756–1791
	Goya, 1746–1828	Schiller, 1759–1805	Cherubini, 1760–1842
	Flaxman (S), 1755–1826	Goethe, 1749–1832	
	Canova (S), 1757–1822	Hölderlin, 1770–1843	Beethoven, 1770–1827
	Blake, 1757–1827	Coleridge, 1772–1834	Weber, 1786–1826
		Wordsworth, 1770–1850	
		Lamb, 1775–1834	
		Scott, 1771–1832	
		Austen, 1775–1817	
	Constable, 1776–1837	Byron, 1788–1824	
	Turner, 1775–1851	Shelley, 1792–1822	Schubert, 1797–1828
		Keats, 1795–1821	
		Stendhal, 1783–1842	Rossini, 1792–1868
	Ingres, 1780–1867	Manzoni, 1785–1873	Donizetti, 1797–1848
	Overbeck, 1789–1869	Pushkin, 1799–1837	Meyerbeer, 1791–1864
	Géricault, 1791–1824	Balzac, 1799–1850	
	Barye (S), 1796–1875	Hugo, 1802–1885	
	Corot, 1796–1875	Heine, 1797–1856	
	Delacroix, 1798–1863	Tennyson, 1809–1892	Mendelssohn, 1809–1847
	Greenough (S), 1805–1852	Browning, 1812–1889	Chopin, 1810–1849
	Powers (S), 1805–1873		Schumann, 1810–1856
19th Century	Daumier, 1808–1879		Berlioz, 1803–1869
	T. Rousseau, 1812–1867	Dickens, 1812–1870	Liszt, 1811–1886
	Millet, 1814–1875	Thackeray, 1811–1863	Wagner, 1813–1883
	Courbet, 1819–1877	Trollope, 1815–1882	Verdi, 1813–1901
		George Eliot, 1819–1880	Gounod, 1818–1893
		Poe, 1809–1849	
		Emerson, 1803–1882	
		Hawthorne, 1804–1864	
		Thoreau, 1817–1862	
		Baudelaire, 1821–1867	
		Flaubert, 1821–1880	
		Turgenev, 1818–1883	
		Dostoevsky, 1821–1881	
		Melville, 1819–1891	
	Inness, 1825–1894	Whitman, 1819–1892	
	Carpeaux (S), 1827–1894		
	D. G. Rossetti, 1828–1882		
	Manet, 1832–1883	Arnold, 1822–1888	Franck, 1822–1890
	Degas, 1834–1917	Meredith, 1828–1909	Smetana, 1824–1884
	Fantin-Latour, 1836–1904	Ibsen, 1828–1906	Bruckner, 1824–1896
	Homer, 1836–1910	Tolstoy, 1828–1910	Brahms, 1833–1897
	Richardson (A), 1838–1886	Dickinson, 1830–1886	Saint-Saëns, 1835–1921
	Cézanne, 1839–1906	Mark Twain, 1835–1910	Bizet, 1838–1875
	Monet, 1840–1926	Zola, 1840–1902	Moussorgsky, 1839–1881
	Rodin (S), 1840–1917	James, 1843–1916	Tschaikovsky, 1840–1893
	Renoir, 1841–1919	Verlaine, 1844–1896	Dvořák, 1841–1904
	Wagner (A), 1841–1918	Mallarmé, 1842–1898	Massenet, 1842–1912
	Eakins, 1844–1916	Rimbaud, 1854–1891	Grieg, 1843–1907
	H. Rousseau, 1844–1910	Hardy, 1840–1928	Rimsky-Korsakoff, 1844–1908
	Cassatt, 1845–1926	Hopkins, 1844–1889	Fauré, 1845–1924
	Ryder, 1847–1917	Shaw, 1856–1950	
	Gauguin, 1848–1903		
	Van Gogh, 1853–1890		
	Sargent, 1856–1925		
	Sullivan (A), 1856–1924	Chekhov, 1860–1904	d'Indy, 1851–1931
	Seurat, 1859–1891		

163

Visual Arts*	Literature	Music
Ensor, 1860–1949	Hauptmann, 1862–1946	Elgar, 1857–1934
Maillol (S), 1861–1944	Maeterlinck, 1862–1949	Puccini, 1858–1924
Remington, 1861–1909	D'Annuncio, 1863–1938	Mahler, 1860–1911
Munch, 1863–1944	Yeats, 1865–1936	Wolf, 1860–1903
Kandinsky, 1866–1944	Darío, 1867–1916	Debussy, 1862–1918
Pevsner (S), 1866–1962	Pirandello, 1867–1936	R. Strauss, 1864–1949
Nolde, 1867–1956	Gide, 1869–1951	Sibelius, 1865–1957
Wright (A), 1867–1959	Dreiser, 1871–1945	Joplin, 1868–1917
Behrens (A), 1868–1940	Proust, 1871–1922	
Matisse, 1869–1954		
Marin, 1870–1953		
Sloan, 1871–1952	Hofmannstal, 1874–1929	Vaughn Williams, 1872–
Rouault, 1871–1958	Frost, 1874–1963	1958
Beardsley, 1872–1898	A. Lowell, 1874–1925	Ives, 1874–1954
Maillart (A), 1872–1940	Stein, 1874–1946	Schönberg, 1874–1951
Mondrian, 1872–1944	Mann, 1875–1955	Ravel, 1875–1937
Eliel Saarinen (A), 1873–1950	Rilke, 1875–1926	
A. Perret (A), 1874–1954	Cather, 1876–1947	
Milles (S), 1875–1955	Marinetti, 1876–1944	
Brancusi (S), 1876–1957	Hesse, 1877–1942	
	Sandburg, 1878–1967	
Klee, 1879–1940	Apollinaire, 1880–1918	
H. Hofmann, 1880–1966	Joyce, 1882–1941	Bartók, 1881–1945
Epstein (S), 1880–1959	V. Woolf, 1882–1941	Stravinsky, 1882–1971
Picasso, 1881–1973	Kafka, 1883–1924	
Boccioni, 1882–1916		
Braque, 1882–1963		
Hopper, 1882–1967		
Gropius (A), 1883–1969		
Orozco, 1883–1949		
Sheeler, 1883–1965	D. H. Lawrence, 1885–	Berg, 1885–1935
Beckmann, 1884–1950	1930	
	Lewis, 1885–1951	
Modigliani, 1884–1920	Pound, 1885–1972	Villa-Lobos, 1887–1959
Manship (S), 1885–1966		
Mies van der Rohe (A), 1886–1969	Eliot, 1888–1965	
Rivera, 1886–1957	O'Neill, 1888–1953	
Arp, 1887–1966	Cocteau, 1889–1963	
Duchamp, 1887–1968	Mistral, 1889–1957	
Le Corbusier (A), 1887–1965	Pasternak, 1890–1960	Prokofiev, 1891–1953
O'Keeffe, 1887–	H. Miller, 1891–1980	Milhaud, 1892–1974
Albers, 1888–1976	Cummings, 1894–1962	Honegger, 1892–1955
Benton, 1889–1975	Dos Passos, 1896–1970	Piston, 1894–1976
Ernst, 1891–1976	Faulkner, 1897–1975	Hindemith, 1895–1963
Lipchitz (S), 1891–1973	F. S. Fitzgerald, 1896–	Sessions, 1896–
	1940	Thomson, 1896–
Miró, 1893–	T. Wilder, 1897–1975	Gershwin, 1898–1937
Moholy-Nagy, 1895–1946	Brecht, 1898–1956	Harris, 1898–1979
Aalto (A), 1898–1976	García Lorca, 1898–1936	Copeland, 1900–
Calder (S), 1898–1976	Borges, 1899–	K. Weil, 1900–1950
Moore (S), 1898–	Hemingway, 1899–1961	Dellapiccola, 1904–1975
Giacometti (S), 1901–1966	Nabokov, 1899–1977	Shostakovich, 1906–1975
Hayter, 1901–	Steinbeck, 1902–	
L. Kahn (A), 1901–1974	Neruda, 1904–1973	

	Visual Arts*	Literature	Music
20th Century	Breuer (A), 1902— Rothko, 1903–1970 Dali, 1904— De Kooning, 1904— Newman, 1905–1970 P. Johnson (A), 1906— D. Smith (S), 1906–1965 Max Bill (S), 1908— Vasarely, 1908— Kline, 1910–1962 Eero Saarinen (A), 1910–1961 Louis, 1912–1962 Pollock, 1912–1956 J. Lawrence, 1917— A. Wyeth, 1917— Lichtenstein, 1923— Segal (S), 1924— Rauschenberg, 1925— Alechinsky, 1927— Oldenberg, 1929— Johns, 1930— Warhol, 1930 Wesselman, 1931—	Sartre, 1905–1980 Sholokhov, 1905— R. P. Warren, 1905— Auden, 1907–1973 Moravia, 1907— S. de Beauvoir, 1908— T. Williams, 1912— Ionesco, 1912— Camus, 1913–1960 Burroughs, 1914— Ellison, 1914— Bellow, 1915— Böll, 1917— R. Lowell, 1917–1977 Solzhenitsyn, 1918— J. Jones, 1921— Kerouac, 1922–1965 Vonnegut, 1922— Mailer, 1923— J. Baldwin, 1924— Ginsberg, 1926— Roth, 1933—	Menotti, 1911— Cage, 1912— Bernstein, 1918— Webern, 1918–1945 Foss, 1922— Berio, 1925—

Chinese Chronology	Japanese Chronology
Neolithic ca. 5000–ca. 1500 B.C. Shang ca. 1523–ca. 1028 B.C. Chou ca. 1027–256 B.C. Ch'in 221–206 B.C. Han 206 B.C.–A.D. 220 Three Kingdoms 221–265 Chin 265–420 Southern Dynasties 420–589 Northern Dynasties 386–581 Sui 581–618 T'ang 618–906 Five Dynasties 907–960 Sung 960–1279 Yüan 1279–1368 Ming 1368–1644 Ch'ing 1644–1912 The Republic of China 1912— The People's Republic of China 1949—	Prehistoric Period before A.D. 552 Asuka Period (Suiko) 538–645 Nara Period 645–794 Heian Period 794–1185 Kamakura Period 1185–1334 Namboku-Chō 1334–1392 Muromachi Period (Ashikaga) 1334–1573 Momoyama Period 1573–1615 Edo Period (Tokugawa) 1615–1868 Modern Period 1868— Meiji Period 1868–1912 Taishō Period 1912–1926 Shōwa Period 1926—

INDEX

INDEX

Italicized numbers refer to illustrations